W9-DFH-700

WISCONSIN

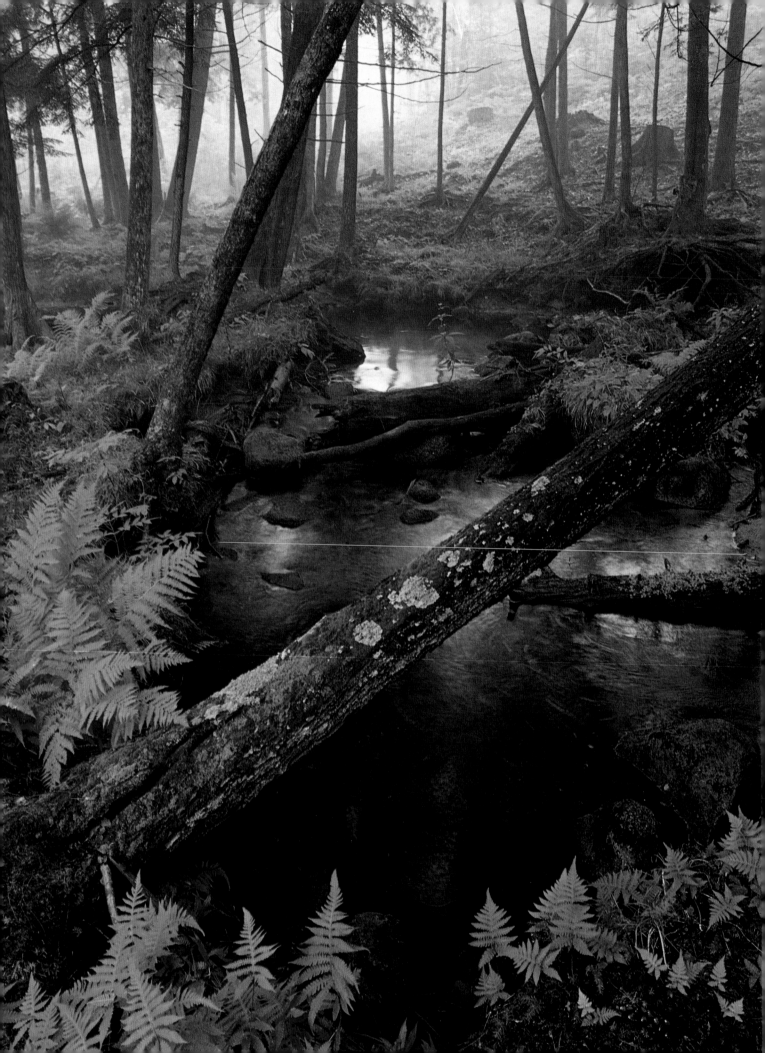

WISCONSIN

By Brent Haglund

PRESS, INC

BOX 1360 MINOCQUA, WISCONSIN 54548

© 1991 NorthWord Press, Inc.

Published by:

Northword Press, Inc.
P.O. Box 1360
Minocqua, WI 54548

ISBN 1-55971-115-9

Cover designed by Mary Shafer
Interior designed by Moonlit Ink, Madison, Wisconsin

For a free catalog describing NorthWord's line of books
and gift items, call toll free 1-800-336-5666.

All rights reserved. No part of this book may be reproduced or
transmitted in any form or by any means, electronic or
mechanical, without the written permission of the publisher.
Copyrights on all photographs contained herein are the property
of the photographer. No photograph in this book may be
reproduced in any form without the express written consent
of the photographers.

Printed in Singapore through Palace Press.

Library of Congress Cataloging-in-Publication Data

Haglund, Brent.
 Wild Wisconsin / Brent Haglund.
 p. cm.
 ISBN 1-55971-115-9 : $24.95
 1. Natural history--Wisconsin. 2. Natural history--Wisconsin-
-Pictorial works. 3. Wisconsin--Description and travel--1981-
4. Wisconsin--Description and travel--1981--Views. I. Title.
QH105.W6H34 1991
 508.775--dc20
 91-21286
 CIP

(Overleaf)

In parts of Wisconsin, groundwaters produce springs whose cold,
mineralized waters challenge the growth of all but the slowest-growing
tree species, such as White cedar. *Photo by Barb Schoenherr*

OVERSIZE

QH
105
.W6
H34
1991

8051689

CONTENTS

UWEC McIntyre Library

DISCARDED

EAU CLAIRE, WI

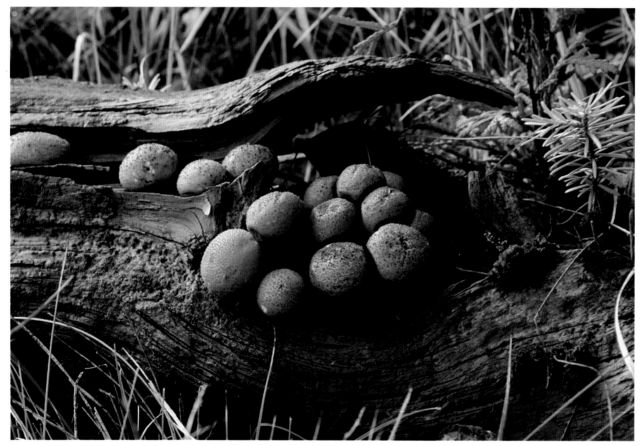

The fruiting body of this mushroom species is about all that we see and know, but within the log, mile after mile of thread-like structures make the most of the nutrition available in this fallen, barkless wood. The thread-like structures make up most of the actual body of the mushroom, and unlike the fruit, are active and present all the time. The decaying activity of fungi like this mushroom contributes to the fresh scent of a walk through any Wisconsin forest.

Photo by Peggy Morsch

INTO WISCONSIN
ON ITS LARGEST RIVER

We start from Prairie du Chien. Our object is wild Wisconsin. We are looking for the places man has left untrammeled and unspoiled. We seek the places where nature flourishes as it has for centuries, before the explorers, the trappers, the farmers and the foresters left their mark on the land. Our journey will be marked by terms of sharp contrast: fire and ice, open prairies and dense forests, excess and conservation. How nature has coped with this complex history suggests that wild Wisconsin will endure as an evolving, dynamic and vital system.

Much of the first portion of the journey will be on the namesake river of the state. And with the nature of this journey established, gravity will not be in our favor during most of our traveling to find wildness in Wisconsin.

We launch, however, from the east shore of the "Father of Waters," the Mississippi River. This is in keeping with journeys over hundreds of years before our time and travels. As we settle into the seats, or into the kneeling position favored by traditionalists, our canoe settles into the current.

This is the current that has sustained its flow for thousands of years. The current has its origins in geologic, not historic, time. This current drained much of Glacial Lake Aggasiz when ice blocked its drainage to the north, and drained all of Glacial Lake Wisconsin down the same river valley through which we travel. The current descends because gravity compels it. It moves toward an eventual settling into the sea though a man-made series of sluices that supplanted the river's delta into the Gulf of Mexico. It is ironic that we moderns use the symbol for the Greek letter delta to represent change; we have changed beyond recognition the area where the continent's major watershed pours into the ocean.

Our canoe settles into this same current that within recorded time hurried a U. S. Army gunboat to a massacre at Bad Axe, that hugged flatboats loaded with British goods to exchange for furs, that helped Father Marquette into new French territory, and that handled Native American canoes and dugouts for centuries before.

Shapes of wild features change. The Wisconsin landscape's present surface patterns might be as unrecognizable to Chiefs Black (Sparrow) Hawk and Decorah as the present Mississippi River outlet would be to early European explorers. But some physical forces are inexorable. In combination they will force the re-establishment of the pattern of the once wild shape if left to their own devices. Gravity and time will again achieve a fan-shaped delta for the Mississippi River. We can count on it.

Wild creatures in Wisconsin change too. A mere few are lost for all time. Most native plants and animals that graced the land and waters at the time of Father Marquette's cursory inspection are still present and accounted for. Biological forces persist, also, in the face of human suppression and control. The tenacity of Wisconsin's wild things is not at an end. Nature's inherent tendency to increase

the number of living things within each kind can be counted upon.

The question then becomes, can we count on human commitment to see that these wild species and their habitats thrive?

In our canoe we stay along the east bank. The Mississippi's east channel in the Prairie du Chien vicinity moves somewhat faster than the sluggish waters immediately below a corps of engineers' lock and dam. The slower waters accumulate the sediment that arrives by the never-ending ton. Sometimes several inches of dirt fill in the area below the dam in a year.

But in the east channel we are on top of the current and rare animals are under our canoe. Below us, and out of sight, lives the Higgins' eye pearly mussel. These animals are often as old as middle-aged humans but have a quite different diet: algae, small animals, bacteria and other small tidbits that the river brings near. Inside the shell and under the layer of the animal called the mantle are gills which collect particles from the incoming water, segregate the particulate food from the junk in the manner we would discard a paper cover of a fast food hamburger, and move the food in threads of mucus into the stomach.

Until recently these rarest of rare wild animals in Wisconsin had the east channel at Prairie du Chien as some kind of retreat. Barges now load and unload grain and a few other bulk commodities there, and the Higgins' eye pearly mussel is no match for the churning propellers of the tugs.

Barge damage and its disruption of habitat are a few of several life threats to these clams. These mussels may not be able to carry out a complete reproductive cycle. Fertilization is done among clam neighbors of which there needs to be a sufficient number. An even tougher job comes in transferring the embryos to a fish.

The little clams are parasites in the gill area of a host fish. For the past several decades, the host fish, skipjack herring, has not lived on the upper Mississippi River.

Skipjack herring were abundant in the big waters of the ancestral Mississippi River. They made runs up and down the big river and perhaps jaunts into tributaries. But until the re-emergence of a few fish in the late 1980's, these hosts to mussels were eliminated. It is also likely that successful clam reproduction was eliminated. A few beds of Higgins' eye pearly mussels have persisted in the face of commercial clamming, pollution and barge traffic without the means to replenish themselves. It is a part of wild Wisconsin that has needed another part of wild Wisconsin to sustain its own life.

Securing our object of wild Wisconsin will be more rewarding, the more we commit to seek it. It will be easier than the struggle of a "pregnant" Higgins' eye to unload its babies absent the host fish species.

But it is time to stop dodging the barges and pondering the clams. Get ready to turn. Shortly after the barge loading docks and bridge, the orange-hued Wisconsin River flows into the Mississippi. Our first move into Wisconsin may get a boost from an eddy as the two flowing waters tumble over and through each other along their edges.

Get ready to seek out the low velocity flow. We can move our canoe upstream on the Wisconsin. A pole may help, but paddles will do the job if we choose our path carefully. A hint: stay by the bank. The opposing current will be slowed by friction from the shallow bottom and will be deflected by the occasional snag.

By staying near the bank we get closer to the raccoon who is waiting for us to pass before grabbing another crayfish. Although it may sound like a family of

birds, the twitters and chirps we hear come from a raccoon family communicating to stay close together for safety. Along the bank we also come upon mink slides that are miniature versions of those made by their larger relative, the otter. We may also smell the scents left behind by the slender weasels and know by that odor that they are kin to skunks.

These mammals concentrate on waterways because that is where better habitat is located. In some parts of present Wisconsin, these mammals are found only on waterways. The rest of the landscape is inhospitable.

The broad valley through which we move has flood plain forests along many river stretches. The forests are narrower than Father Marquette saw. These flood plain forests offer a level of protection if they are within the state of Wisconsin's Lower Wisconsin River Project ownership. The flood plain forests are good habitat for river mammals and much more.

Within a flood plain of a river, food gets a broader distribution than along a steep bank. Shelter for escape from predators and inhospitable weather is more easily found, and the three dimensions of a forest make life's chances better for mink, otter, skunk and raccoon.

In a few places along the flood plain forests, the mammals common to Wisconsin's waterways find a special favor each season. That favor to these furry carnivores is nesting season and brood rearing time for great blue herons, great egrets and other fish-eating birds that choose flood plain forest trees to establish rookeries. Many young birds do not fledge. In some years, the fish, frogs, toads, salamanders and other creatures that tempt the herons' palates are woefully insufficient. Then most young birds die. Even in good years some are abandoned, or, just as likely, find themselves on the bad end of a shove from a larger nestmate.

The nature of the misfortune that has cast a young heron or egret to the flood plain forest floor from the nest atop a silver maple is of no concern to the prowling raccoon or mink. Food is food, and the bigger the better for the mammal with its own young to feed. An ecological food chain that seems so neat in a biology textbook seems to unravel in its complexity at the rookery. Carnivore eats carnivore, which had probably been fed another carnivore, a fish, by one of its parents.

In late summer, with low water levels in the lower reaches of Wisconsin's biggest river, a wall of green seems to rise up from the silts at the top of the river cutbank. The traveler who stops the canoe carefully by landing with the bow into the current and ventures through the "green wall," is to be commended for intrepidity in the face of prickly ash, stinging nettle, poison ivy, mosquitoes and other bearers of thorn and poison.

The traveler may find an expanse of what looks to be more of the same: clinging vine, thorny bush and buzzing insect. Or, we may find relatively clear travel. The more frequently used high water passages of the Wisconsin River may be as easily passable as a walk on bare sand. Other channels may have enough flow at high water time now and again to be uninhabitable by woody shrubs but passable for a human on foot. If the woods has passed some decades since the last logging, the shade from tall, mature trees may be effective in removing those plants which hinder travel on foot. So we move into what we hope to be an old woods of large flood plain trees.

The habitat produced by mature wild trees is a vital part of our North American heritage. These intact forests produce a quiet, peaceful environment for the mind, and are uncommon in modern Wisconsin. Cutting of all the ancestral forests was

essentially completed within less than a century of European settlement in Wisconsin.

The wild Wisconsin that is our object is never to be encountered in an ancestral forest. Only a few regenerated stands have been essentially left alone. Some of these will be flood plain forests of silver maple, basswood, swamp white oak and, in the sunnier places, sprouts of American elm, willows of different kinds, both black and white ash, plus other deciduous species.

American elms thrive in very few locations now, if they thrive at all. The fungus which clogs the sap movement is carried by a beetle which moves from tree to tree. Unlike the severe and rapid demise of chestnut trees on this continent early in this century, Dutch elm disease has been laying elms low over decades not years. In many forests young American elms rise up and seem able to live five to ten, perhaps even fifteen years before succumbing.

This becomes an aspect of variation from one flood plain forest to another. And if big elms, most likely dead, are still standing, we may find the "ceiling to floor" excavations of the pileated woodpecker. These loudly calling birds are on the prowl for the insect larvae which make a living out of the very low quality food of elm tree boles. With small elms, the pileated woodpecker, Wisconsin's largest woodpecker, just passes on through with a characteristic "wingbeat, wingbeat, wingbeat and glide" undulation amidst the trees. Downy woodpeckers may find a dying young elm a serving table for insect treats, though. Their smaller size is more compatible with the narrow diameters of young trees and smaller branches.

A place where our canoe might go further and still allow us to move at the edge of a flood plain forest is at the junction of the Kickapoo River and the Wisconsin. Here is one of Wisconsin's finest flood plain forests which is now protected and publicly owned but came within a chainsaw blade and a deed of becoming just another pile of big tree sawdust.

A hard left turn is required out of the Wisconsin and into red-shouldered hawk habitat at the mouth of a long "driftless area" stream.

The shrill call of the red-shouldered hawk, a bird far more often heard than seen, resonates through this forest's large, mature trees. Now we experience quality of a higher plane. Could walking through this forest reward us with a glimpse of the bird? Could we find the nest on a shady day when searching among the branches and boles of these trees? Is it more effective to search on bright days of harsh sun and deep shadow? If we found the nest could we discover what the parent birds were bringing to feed their young? If we saw the mated pair sitting side by side at the nest could we establish which was male and which was female?

On a smaller scale, but of equivalent ecological function in this forest of wild Wisconsin, is the prothonotary warbler. Like the red-shouldered hawk it is a carnivore eating at the end of a long food chain. A sharp beak, not strong talons, does most of the food catching work for the prothonotary warbler. Like the hawk species this is a bird of the forested riverways, whose larger forests are the only viable source for successful nesting.

Even if we couldn't rapidly discriminate between the female (larger) and male hawks, we can certainly imagine the many ways in which larger forest expanses benefit native bird species. These species evolved in breeding grounds of flood plain forests typically a hundred or even several hundred times greater in length and continuous tree cover. Although the shape of a flood plain forest is still highly predictable – ribbon-like with quite a length but a narrow cross section – the ancestral

Wisconsin forests of that sort may have been continuous across one to two, occasionally even three, different river intersections.

A larger size produces a more homogeneous microclimate. It also increases the birds' chances for safe dispersal away from the rearing site and reduces predation success for those hungry birds, such as blue jays, that do the greater part of their feeding along the edge of a vegetation stand.

There are other birds to be found here. This particular flood plain forest has some of the higher quality native breeding bird communities to be found across the state. And, despite its middling size compared to the other 49 states, quality habitats such as this one give Wisconsin first place for the greatest number of breeding bird species of any state. Alaska and Montana shrink by this measure of wildness.

Flood plain forests may contain large mature trees and relatively little undergrowth. It is not unusual to find a large cottonwood close to a large swamp white oak. The sprawling canopy of these large trees is part of the explanation for the wide spacing between trees and the relatively small number of saplings we see in a mature flood plain forest. The river itself has more of the explanation to offer. The scouring of some floods, the silt deposits of other floods, and long periods of standing water from some floods kills many young trees. But trees that make it into middle age can grow quickly with abundant water and a large share of the incoming sunlight, each augmenting the other, and both in turn augmented by the fertilizing effect of the silts left by retreating floods. A flood plain forest is also a likely place to see tree-sized poison ivy vines pressed close to the bark of support trees.

If the lower back and shoulder muscles are willing, a move up the Kickapoo River would be a good trip to make. The river is cut into sedimentary rock for much of its length and has had at least several thousand more years than Wisconsin's glaciated rivers in which to confirm its twisting path. The modern explorer has the advantage of arranging upriver or downriver trips on the Kickapoo River. The many water miles that are covered are but a few on the much straighter roads. Never, however, does the Kickapoo turn around on itself like the "Round River" of the mythical Paul Bunyan. But going up river by canoe during a Kickapoo River flood may give one a similar sensation of much exertion with little new distance.

A spring canoe jaunt on the Kickapoo River may put the canoeist close to one of wild Wisconsin's conservation success stories: wild turkeys. Gobblers may be sparring relatively oblivious to the cautious traveler. A hen with poults—a dozen or more are not uncommon—may be seen in the early summer. As in the case of the red-shouldered hawk encountered just downriver, these are birds more likely to be heard than seen.

Just as likely to be heard as the familiar "gobble, gobble, gobble," which descends both in pitch and volume, is the whack of one turkey trying to dislodge another from a desirable tree perch. Or it might be the crashing noises as the dislodged bird tries gamely and often unsuccessfully to put wings to use before it tumbles to the ground.

In just a few years the prolific wild turkey has reclaimed terrain lost to their species for more than a century. The wild turkey reintroduction was done by wildlife managers of the Wisconsin Department of Natural Resources, who added to the gains the birds would make naturally by occasionally trapping excess birds and shipping them to areas where wild turkeys had not yet arrived of their own accord.

These big, brown, but still colorful birds, if one likes understated color, scratch through oak leaves for acorns, patrol corn fields for midsummer ears lowered to their reach by previous raccoon or deer patrols, and would seem to be able to eat hundreds of grasshoppers or crickets a day. These birds are improving for many of us what it means to experience a day afield in Wisconsin's forested areas.

Beyond the zone where the river affected tree growth, the dominant trees along the Kickapoo River were sugar maples. Cutting brought them down and plowing opened up the ground for the first time. Perhaps the wild turkeys would have had less desirable habitat then than the fragments of forest and field in which they now thrive. The flood plain forest would have been much narrower than that of the Lower Wisconsin River, and in many places a dry or mesic, not lowland, forest would have occurred literally to the river's edge.

Further upstream on the Kickapoo River, the forest community is a relic of that which persisted during Wisconsin's glacial activity. Sandstone cliffs may now accumulate ice in the winter that can cause the viewer to think of the glacial ice that threatened this region, influenced the region's climate for thousands of years and yet never obliterated the soil, plants and stream channels here as it did to the east and north.

The ice may persist into the normal growing season for one plant relic. The cool-seeking plant is the northern monkshood found in a few places along the upper Kickapoo River. Look, but don't touch, and certainly don't pick it for its late summer, dark blue blossoms. This plant is on the federal threatened species list, and it is declining in a number of habitats across the nation. Preservation of this species is going to be the relatively simple protection of its remaining cliff or steep bluff habitats together with their immediate surroundings.

The wild turkey and the northern monkshood both are capable of becoming wild Wisconsin conservation success stories. The avenues to success are to be quite different, however. On the one hand, animal trapping, release and hunting are required to sustain the wild turkey and its programs. And, on the other hand, ownership of the real estate on which the northern monkshood presently blooms will insure its existence.

Cattails signal deeper water in a marsh. The belligerent male yellow-headed blackbird sets out to defend a place amidst the cattails and to entice a female to enter the territory, mate with him, and raise their young. Its call is a common sound in many Wisconsin marshes, especially in those of the central state region, like Germania and Horicon. *Photo by Ted Thousand*

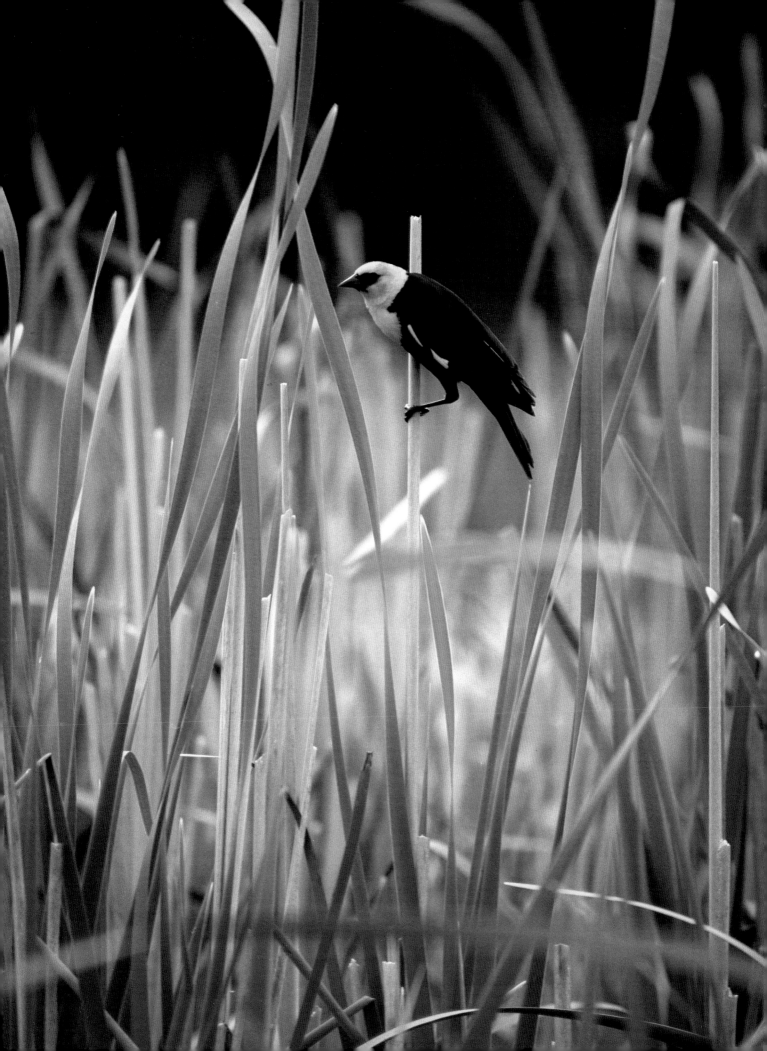

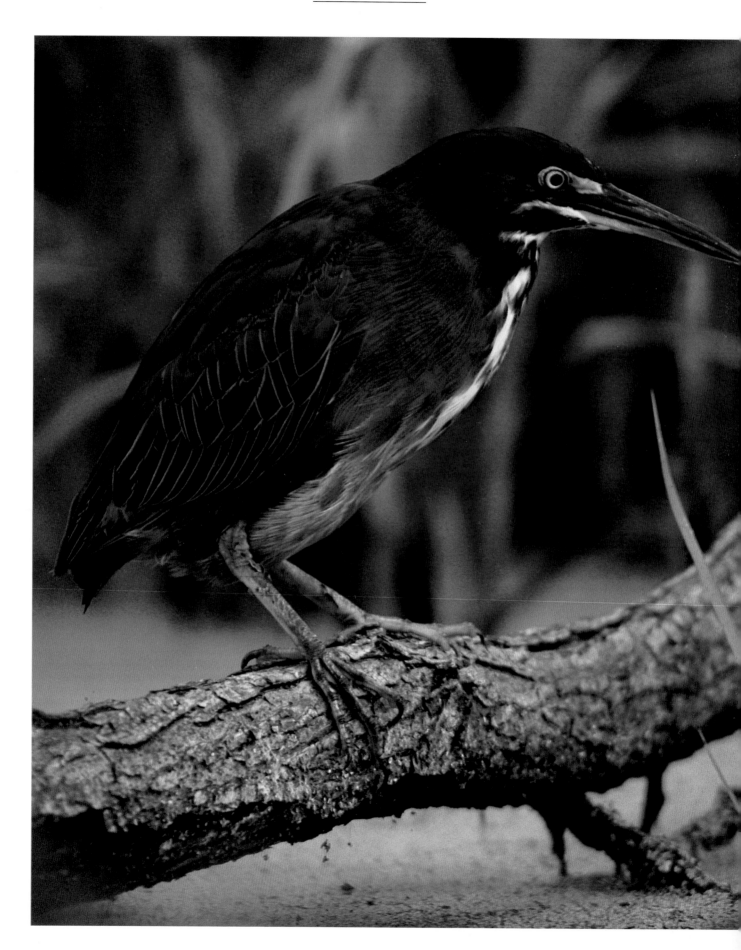

Bracken Pond-ferns. One of many outcomes of the fierce fires that followed Wisconsin's first loggers and the soil erosion and nutrient depletion that were produced by the fires was an expansion of bracken and other fern species. Ferns tolerate poorer conditions than those needed by grasses or other flowering plants. *Photo by Robert Queen, Wisconsin DNR*

Green heron, Fish Lake. Heron species show a range of sizes. Green herons are much smaller than the more easily seen great blue heron. The smaller size means somewhat less food is required for each individual, and smaller animals become worthwhile to catch. Also, lower-lying vegetation can be penetrated without the heron being seen by the prey animals. Conifer stands, including pine plantations, are used for nest locations by green herons. *Photo by Ted Thousand*

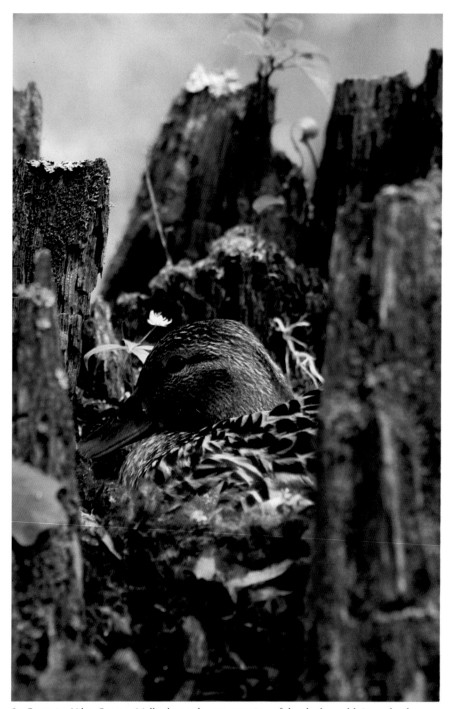

St. Germain, Vilas County. Mallards are the opportunists of the duck world. In parks they are ready for a human handout; at the edge of a forest this hen is snuggled onto her eggs within the cavity of this old cut stump, a vestige of Wisconsin's heavy logging days.

Photo by Robert W. Baldwin

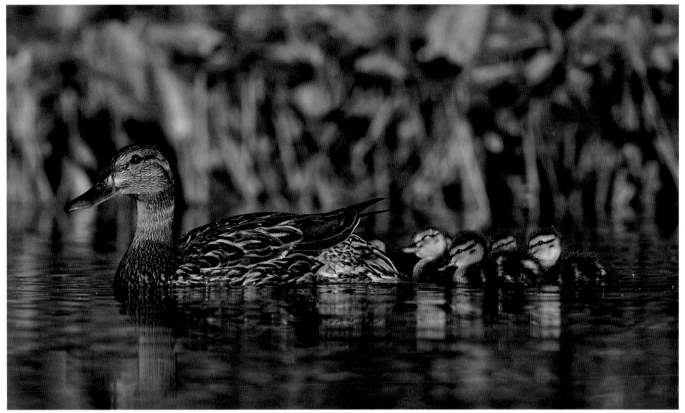

Color is often bright among male birds. The contrast in color between the male and female birds within a species is a reasonable predictor of which of the pair does the most tending of the babies. The brightly colored drake mallard rarely takes the duckling string on a splash, waddle and paddle through the pond. Predators, at least hawks, are preferentially attracted to the more brilliant male, so the drab female's brown color tones give more security to the young.

Photo by Dr. Scott Nielsen

Necedah, Juneau County. Diversity within an ecological system is aided by the complexity of the structure. In the same manner that a hilly terrain is likely to hold more plant species than flat land, trees in a stream provide lodging for animals of the brook. The turbulence that slows the water's advance becomes an advantage to stream organisms like the caddis flies who clean the water by eating small debris and also indicate the kind of habitat favored by trout fisherman who value wild Wisconsin in their own way. *Photo by Mark Wallner*

Eating mosquitos is a way of life for many dragonfly species. For that and other features, we humans appreciate them, especially in the many lake, river and marsh areas of Wisconsin, which are prime breeding grounds for mosquitos. The dragonfly life is one split between water and air. During the brief time of metamorphosis to winged adult, they must rise from the bottom of the lake, pond, or stream in which they have functioned as solitary predators, and free themselves of their last underwater skeleton. Most nymphs never get their wings. They are eaten by fish, salamanders, or frogs.

Photo by John Gerlach

(Overleaf)

Spring is a noisy time in Wisconsin. Birds are calling and other creatures, including this American toad, are identifying themselves to prospective mates by sounding off. The toad's air sacs are inflated along the cheeks behind the jaw and air is vented to make the characteristic high-pitched buzzing sound. *Photo by Barbara Gerlach*

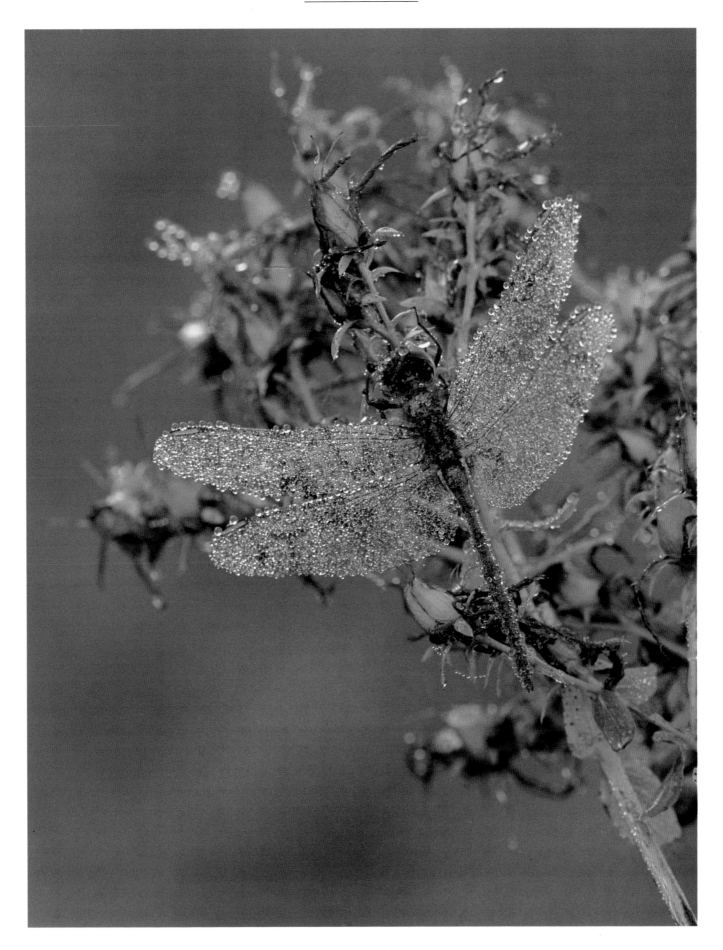

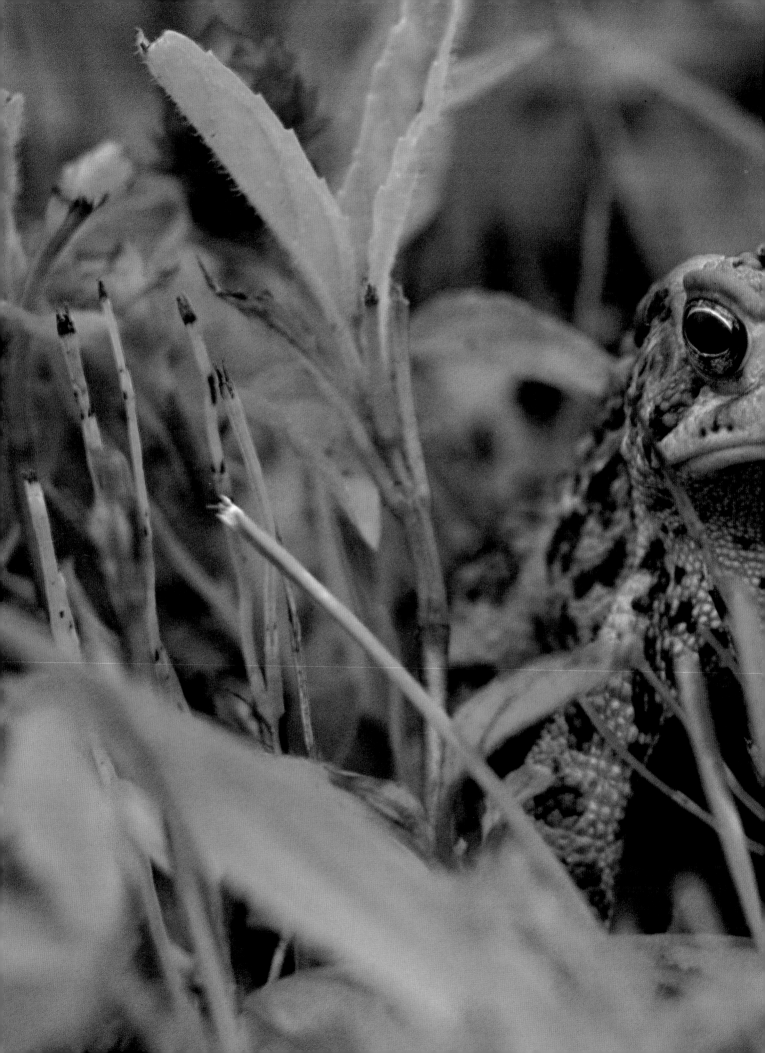

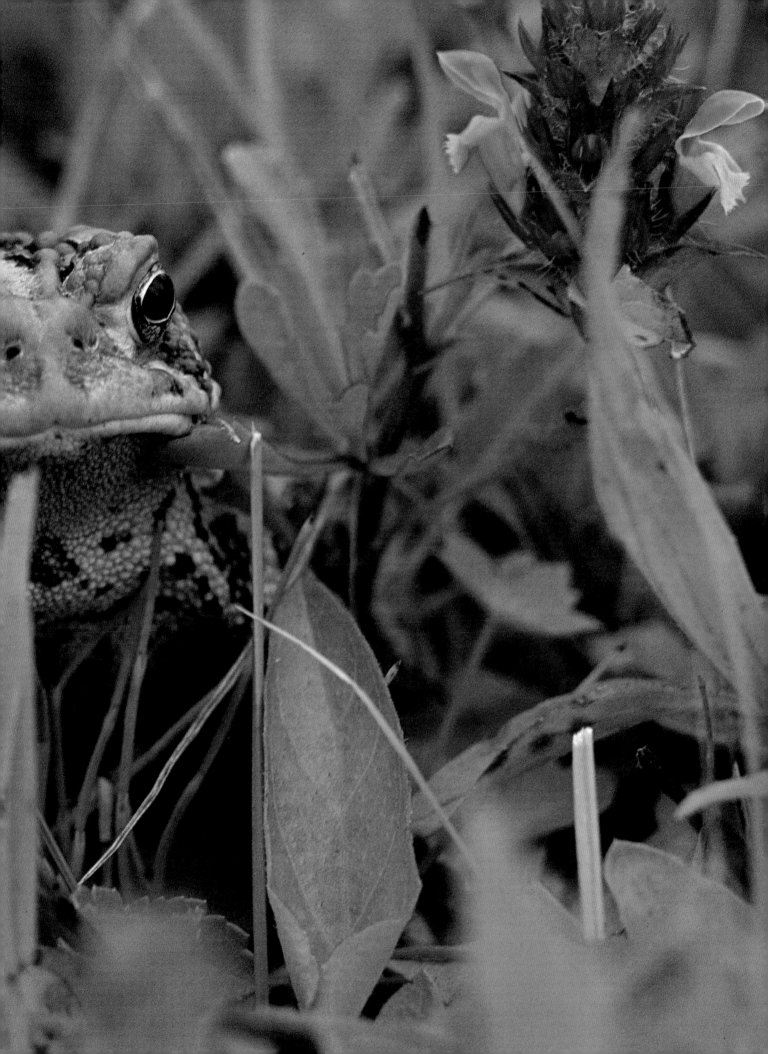

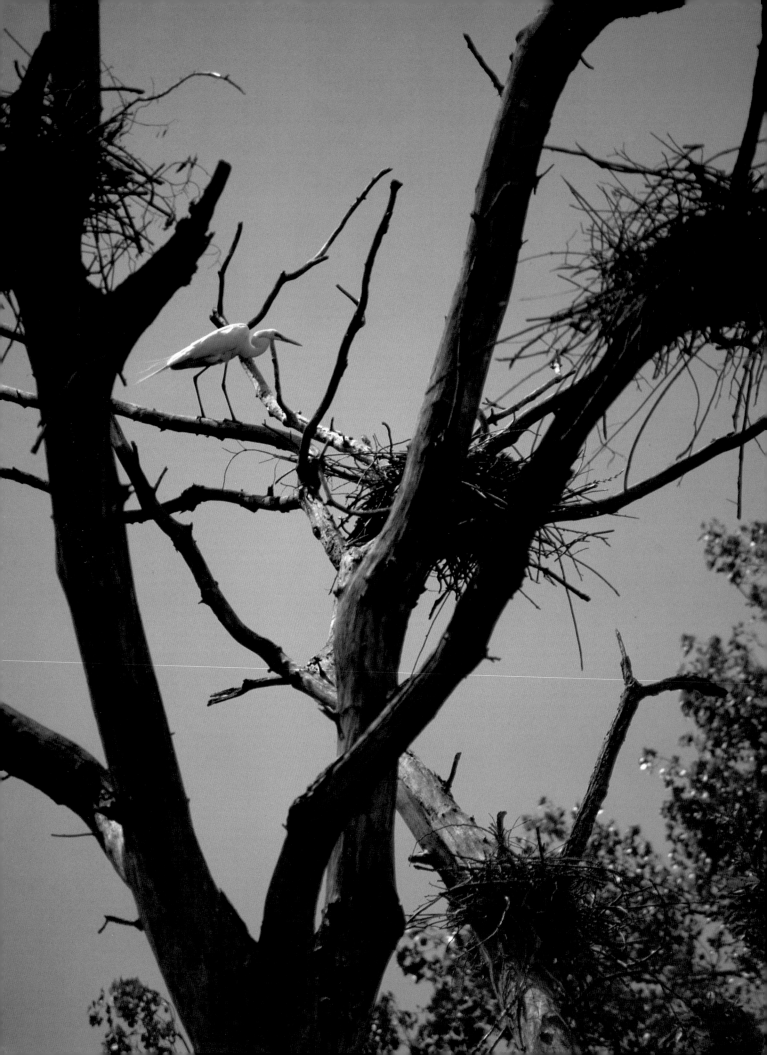

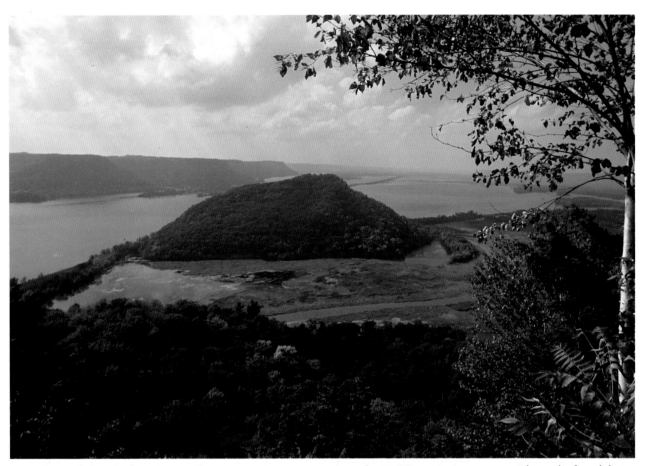

Perrot State Park, Trempealeau County. The expansive river terrace regions of some Wisconsin rivers represent the work of much larger volumes of water in geologic past. Glacial lakes and the melting ice produced quantities unknown, even in the floods of human history.

Photo by Robert Queen, Wisconsin DNR

Horicon Marsh, Dodge County. Colonial nesting made egrets easy targets for the turn-of-the-century plume hunters who sought the egrets' plumes to sell for hat decorations. Colonial nesting has advantages to egrets under other circumstances. Groups of nesting birds may see predators more readily than pairs of adults on individual nests. *Photo by Robert Queen, Wisconsin DNR*

Gently sloping layers of sedimentary rocks are the foundation for much of central and southern Wisconsin's soils and habitats. This small butte is a former island in Glacial Lake Wisconsin and had its sides steepened by wave erosion. Now, it is an island of small but high quality habitat in what may be a vast "ocean" of crops.

Photo by Allen Ruid

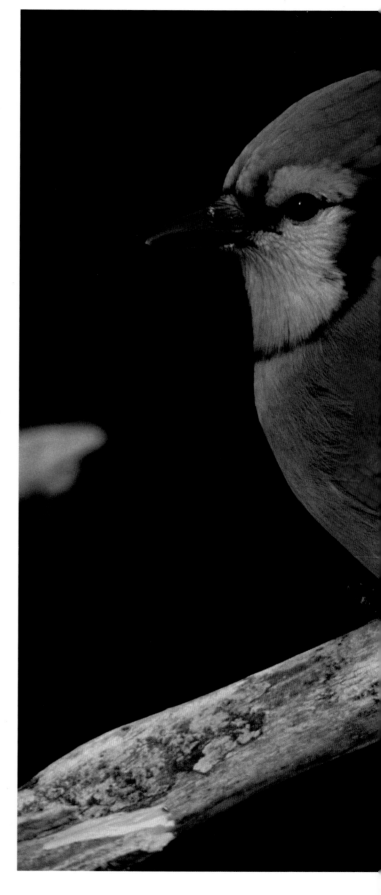

This crested bird feeder occupant has other important functions within the woodlot, forest and suburb besides feeding itself and scattering seeds from the feeder to the dark-eyed juncos waiting on the ground. What the blue jay accomplishes by stashing viable acorns in an abandoned pasture is the beginning of a new hardwood forest or the re-stablishment of a forest which has been displaced by humans.

Photo by Ted Thousand

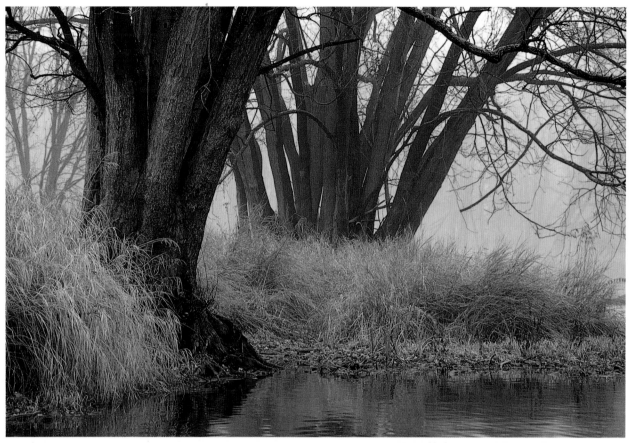

River floodplains process extra running water during occasional storms and the annual snowmelt. The people who study rivers tell us that the shape, depth, and width of the river is established by the stages of the banks. Neither floods nor droughts have much influence. It is the multitude of such rivers that helps make wild Wisconsin so attractive.

Photo by David L. Sladky

The feather-like appearance of these elongated ice crystals signify a still period of steadily falling temperatures. Wild Wisconsin offers its treasures in all seasons to those willing to seek them.

Photo by Don Blegen

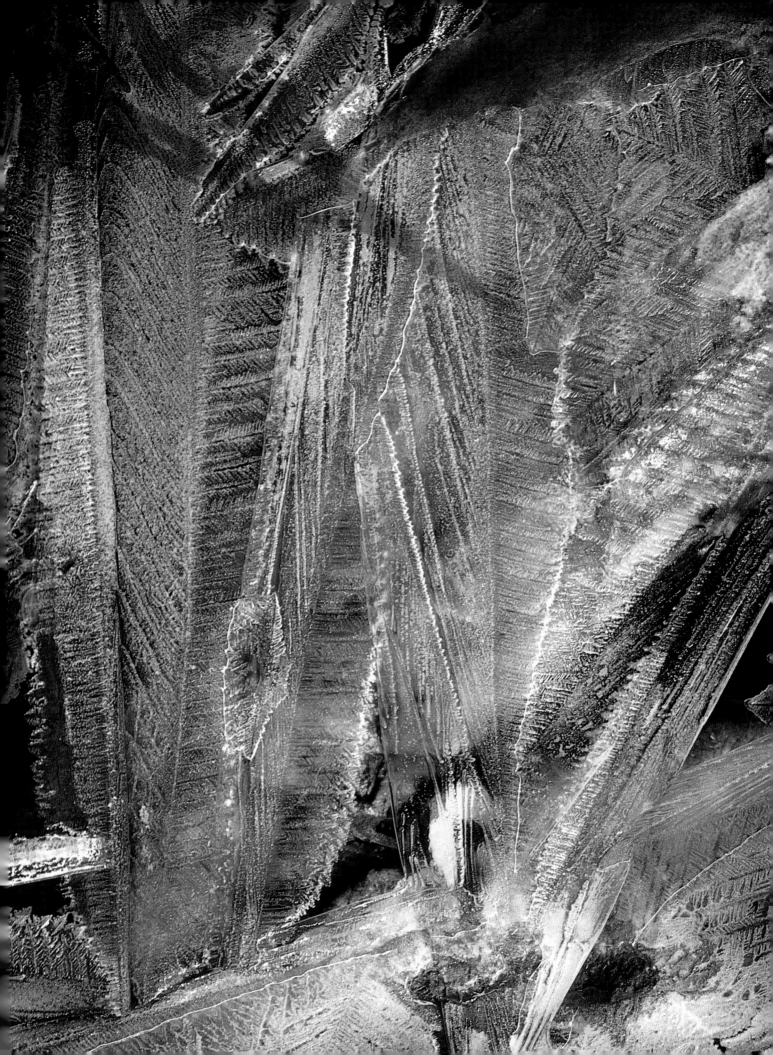

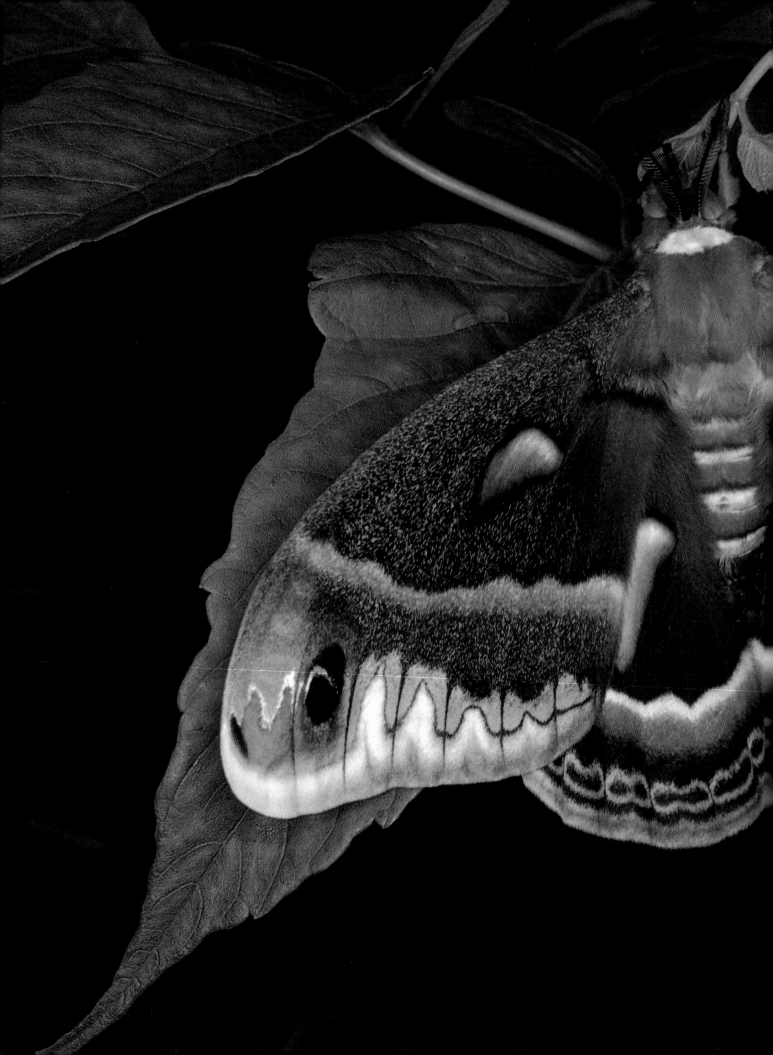

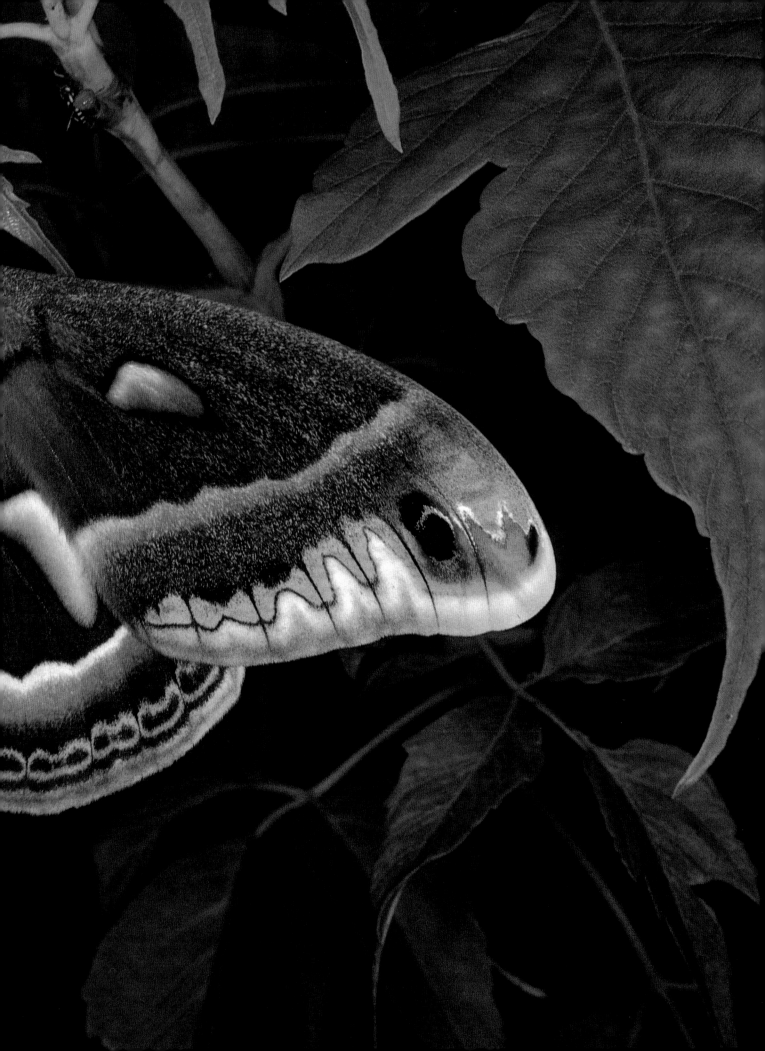

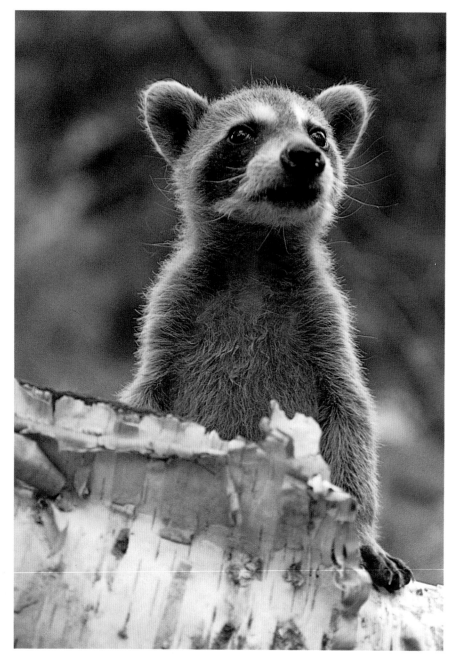

Boulder Juntion, Vilas County. Keeping track of mother is a major part of a baby racoon's day and night. Its mother provides protection and is more likely to find food. Being alone and searching for a new abode will wait until this raccoon reaches the "teenage" stage. All of Wisconsin is populated by this scrappy, omniverous mammal. Even the Wisconsin State Capital grounds in Dane County host raccoons.

Photo by Robert W. Baldwin

The pileated woodpecker is an avid eater of beetles and other insects that live in trees. It is most often dying and dead trees that have enough food to tempt this black, white and red carnivore to feed. Small trees and stands of single species, such as planted red pine woodlots, are virtually useless to pileated woodpeckers. Listen instead, for its piercing cry in forests that have been allowed some measure of maturity and ecological development.

Photo by Gregory K. Scott

(Overleaf)

Cecropia moth. Evening and night belong to the moths, and day belongs to the butterflies. Animal species which seem to bear many similarities are separated from one another in many ways. Activity in different times in the same habitat is a common evolutionary separation.

Photo by Don Blegen

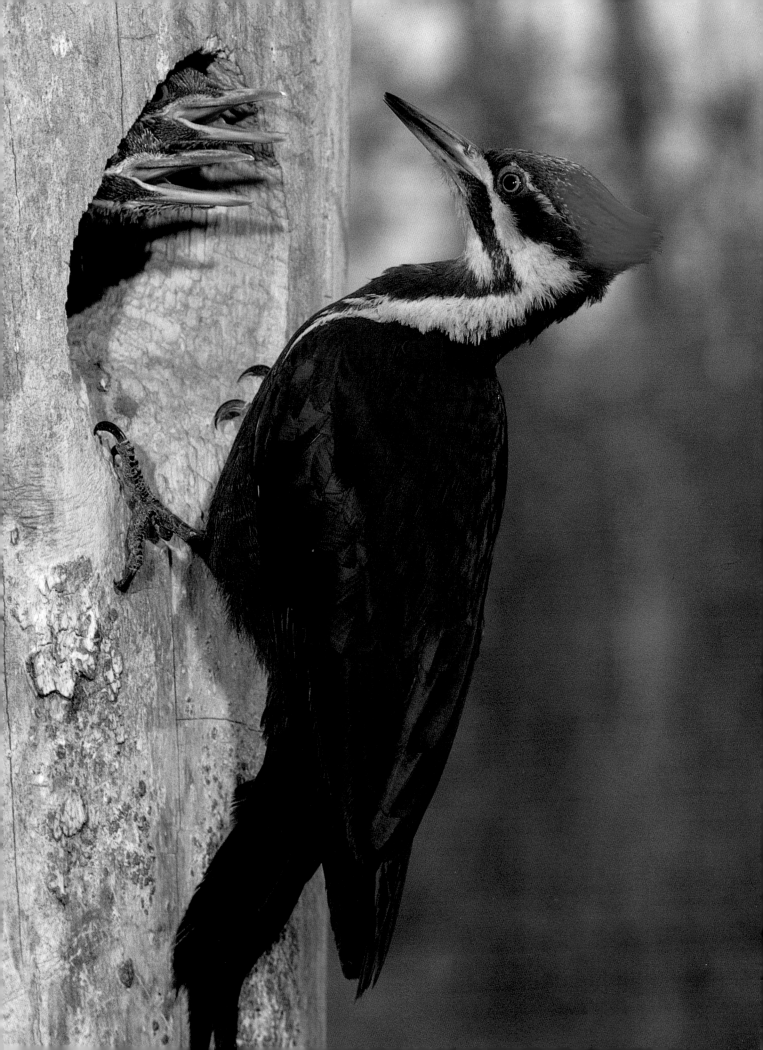

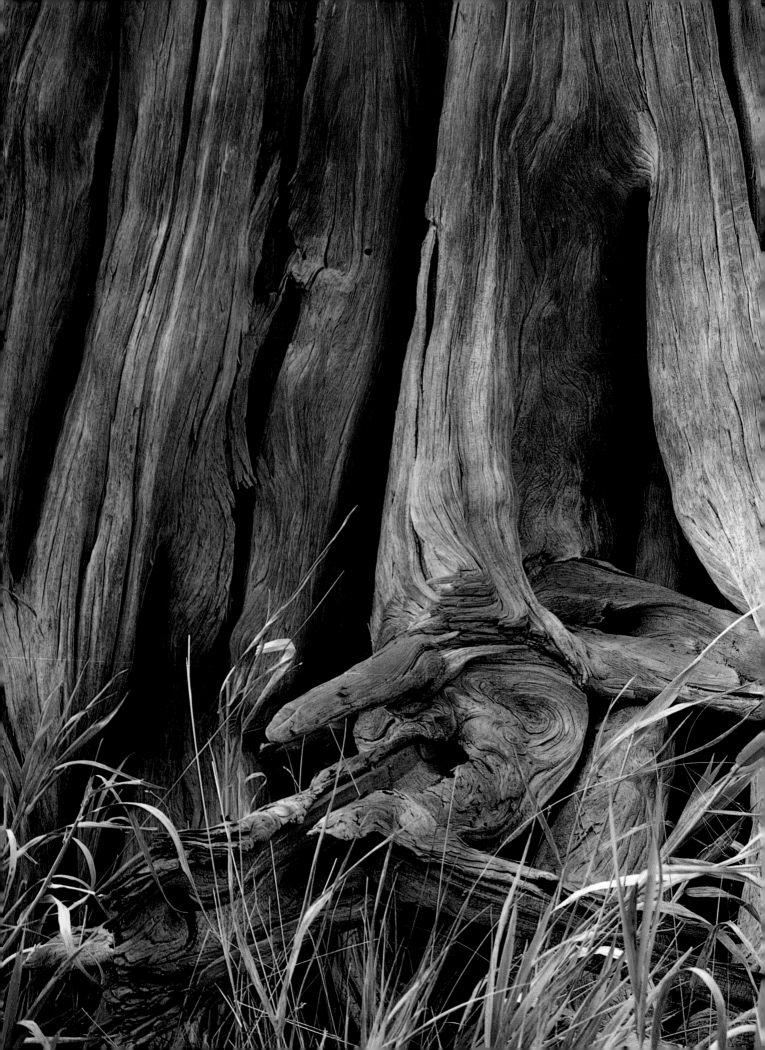

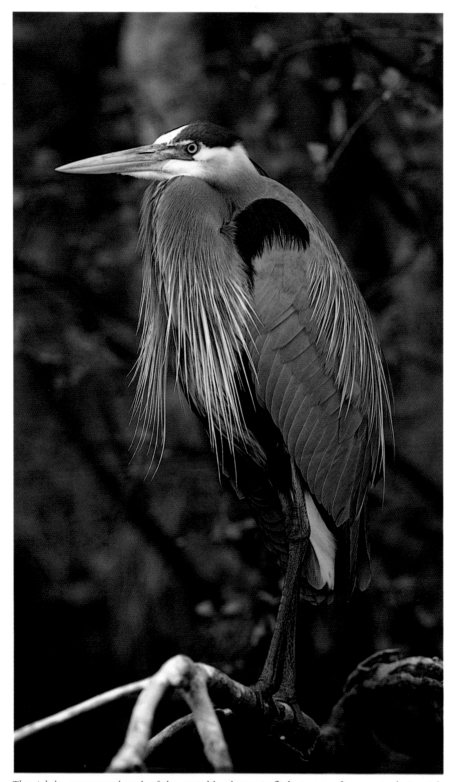

The tightly compressed neck of the great blue heron in flight is a surefire way to distinguish between herons and cranes. Cranes extend their necks. The fish-eating herons and their close kin, the egrets, probably increase their efficiency of flight by bringing their heads close to their bodies.

Photo by Dr. Scott Nielsen

Light and shadow playing on the decaying tree base give it visual interest. The grass moving in on the tree is taking advantage of the brighter sunlight, now that the tree leaves are gone.

Photo by Dr. David Sladky

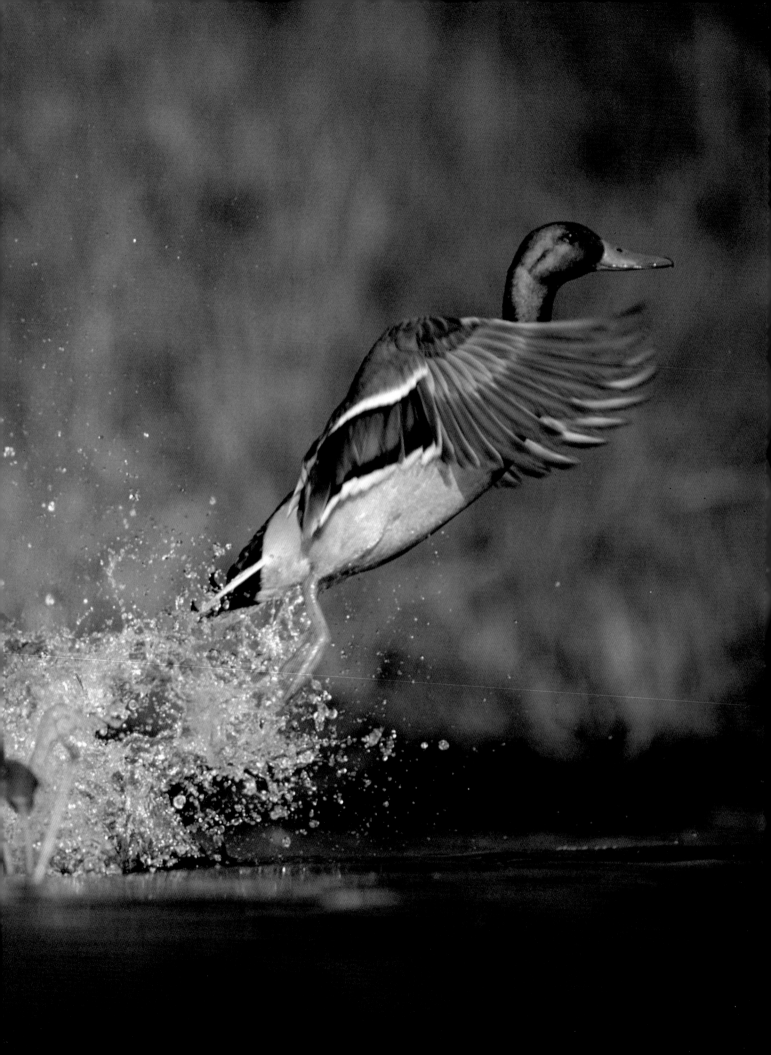

EAST FROM THE KICKAPOO RIVER

The ice that builds a nearly year-long frozen soil for the cliff-dwelling northern monkshood in the driftless area seems out of place amidst some of the warmest areas in Wisconsin. The cliffs of the Kickapoo contrast with the sands of the Lower Wisconsin River. The coldest cliffs face to the north and thereby get the least solar radiation, while the warmest sands are on south-facing slopes and get the most sun.

The origins of the plants tell us much about the how the habitats still function in these distinctly different, but nearby, environments. Northern monkshood and its neighbors on the north slopes have close relatives in the tundra of the arctic and in alpine regions. In fact, natives of the Aleutian Islands brewed a poison from monkshood for coating harpoons and spears used in beluga whale hunts (another good reason not to pick or harm the northern monkshood on Wisconsin cliffs). The prairie plants of the warm south-facing slopes share characteristics with plants common to the Great Plains and, for a few, the Ozarks.

Poison for a whale hunt has little in common with prairie plants such as little bluestem, sideoats grama, Indian grass and hills' thistle. These plants need grazing by bison or wildfires to preserve their grassland environment. The lack of these processes has brought shade, that bane of productive grasslands, to many Wisconsin hillsides that once sustained the bright colors and waving stems of prairie plants.

Red cedar and even basswood trees have usurped prairie sunlight and thereby prairie plant space. Sometimes white birches are the invaders from the ravines where they clung to life in fireproof niches. Our canoe perspective brings into view the red cedar and the white birch of the prairies becoming glades and later forests in southwestern Wisconsin.

The belly of the valley of the Wisconsin River is filled with hundreds of feet of sand from Glacial Lake Wisconsin spewing out this way. As we travel upstream over that sand bottom from the Mississippi to the glacial margin of the ice age, we pass bluffs of sedimentary rock rising above these sands. On our left side these bluffs hold the prairies that are becoming glades and forests. On the equally steep, but much cooler slopes to our right we find several species of oak and hickory and the characteristic shrub plants that give Wisconsin dry forests a common shrubby appearance.

Our travel distance from icy cliffs to dry, warm, sandy slopes is very short. Up out of the water, a walk of one hour or less could easily get us into the former prairies or dry forests. And only a short distance up the Wisconsin River from

One of the largest species of puddle ducks in North America, the mallard is widespread in Wisconsin. Puddle ducks like the mallard erupt nearly straight into the air without the runway that is needed by diving ducks, like the ring-necked duck. *Photo by Dr. Scott Nielsen*

the Kickapoo River's mouth we will experience prairie right up to the river's edge.

The river bank prairies rarely present the "green wall" that greets us with the flood plain forest margin. However, the mosquitoes may be as troublesome on calm days in early summer as they are in the forest. Bird sounds will be quite different, and bird colors are not as bright on the prairie. Perhaps bright displays attract predators as well as mates in the prairie. We have it on good authority, the grumblings of amateur birdwatchers, that prairies hold many species of "little brown jobs," the birdwatcher's catchall for those sparrows down in the grass who are not likely to come out to the beseeching whistle that works so well in the forest.

One of the river bank prairie areas just upstream from the chilly Kickapoo River valley is called Avoca Prairie, close to the village that shares the name. This is the largest of the Wisconsin native grasslands. Some people assert that it is the largest remaining prairie east of the Mississippi River. Since this prairie is about two square miles in area, and since some of the ancestral prairies covered hundreds of square miles, we can call this Avoca Prairie, at best, a prairie fragment.

Watching the waving grasses which pause to straighten and catch a breath before the next wind gust is a pleasure to the eye, trained or novice. Without nearby trees or houses to deliver a sense of scale, the viewer can imagine a native grassland to be just about any depth from inches to feet. In fact, the Avoca Prairie can cover up most people and their hats with grasses holding flowers and later seeds more than eight feet in the air.

The wild prairie may be less a grassland and more a wild garden with members of the daisy and pea families a prominent feature – this according to data compiled by the late John Curtis, a professor at the University of Wisconsin. The better quality prairies have a rich blend of plants that have different ecological roles. Some of the plants convert free molecules of nitrogen in the atmosphere into more useful forms in the soil. Some groups of plants, notably the pea and bean family which has many native prairie species, are noted for their role in this process called nitrogen fixation. The sites in which this transformation takes place are underground and often located on root nodules dense with microorganisms. There is reciprocity here as there often is when a relationship is sustained by mutual needs. The nitrogen-fixing bacteria need simple sugars from the plants to run their bodies; the nitrate and ammonium demanding plants need nitrogen to further growth and well-being.

Lead plant, white and purple prairie clover, and wild indigo are three representatives of the pea and bean family that splash the prairie with color. Throughout a growing season, a prairie of quality will show varying colors. Some of the species bloom for less than a week, attract insect and bird pollinators in that brief interval, and then wither, diverting energy to support the embryonic plants that dwell inside each viable seed.

Bigger splashes of color come with the white, gold and other colors of the inflorescences of the daisy family. Native sunflower species, for instance, have large blooms which are in truth compilations of dozens of particular disk and ray flowers. The common dandelion belongs to this family as do aster species and fleabanes.

The range of vascular (tissue that conducts water and food) plant groups represented within a quality prairie is as broad or broader than other native Wisconsin habitats. Around 1800 vascular plant species call Wisconsin their native home, a plurality of these associated with or restricted to prairie habitats. At the extreme southeastern corner of the state, protected prairie remnants of just a few hundred acres contain over 20 percent of the total plant species of Wisconsin.

WILD WISCONSIN

Divide the number of plant species by 100 and you will come close to the number of reptiles native to Wisconsin. Warm and dry or warm and wet are the simple ends of the spectrum for most reptile habitat. Most reptiles in Wisconsin are close to the high latitude edge of their range, and snakes, lizards and turtles find the best habitat in the driftless area. Close to the Lower Wisconsin River's banks are some of the richest reptile grounds in the entire state.

Because sand dunes exist within walking distance of the Wisconsin River, we can search out the ornate box turtle. This colorful, cute, pet trade species is classified as endangered within the state. Watch for tracks showing a dragging lower shell and footprints about 15 centimeters across from toe to toe. If we follow these tracks we may find the rounded back of this turtle as it dines on plants growing in the sand.

If we get too close with bare feet, we may have cactus spines to remove! True to its kind, the prickly pear cactus has spines that provide a bristling defense (though not an impenetrable one, as the ornate box turtle makes it an occasional meal).

There are several cactus species in wild Wisconsin and they seem to share common habitat with cold-blooded reptiles. Besides the sluggish turtles, native reptiles include the six-lined racerunner lizard, a glass lizard which appears to be a snake because it has no legs, the long—up to six feet—mouse-eating bull snake, and the hognose snake. The last mentioned reptile is a wonderfully active animal to observe. It seems belligerent and aggressive when these tactics might drive away a foe, but rolls onto its back and feigns death as the foe closes in. Pick up the trickster and place it on its belly, and it will roll over and play dead again.

The warmth of the sun on the sandy soil makes life tolerable for reptiles of the Wisconsin River valley. A native prairie remnant or even an oak barrens-type savanna (trees scattered among grasses and low-lying plants) lets enough sunlight in to warm the ground. Reptiles absorb this heat to warm up, digest food better, and to elevate metabolisms to make feeding more effective.

Dense trees trap the sun first. The tree lines put in place to trap the wind are solar traps, too. Many lines of red, white or jack pine, and sometimes even white spruces, emerged along property boundaries during the dust bowl era in this expansive valley. Indeed these lines seemed to slow soil loss by wind erosion, but also accelerated the decline of native reptile populations both directly and indirectly. Soil close to the trees is too cool for reptiles to tolerate. This creates an effective barrier to travel which grows larger in area with each year.

Fire suppression to protect these trees removed the necessary fires from the prairies. Woody plants filled in quickly, excluding prairie grasses and flowers as well as the once abundant reptiles. However, purchasing property for native habitat preservation, followed in succession by cutting and the careful reintroduction of fire, works wonders in Wisconsin's surrogate desert.

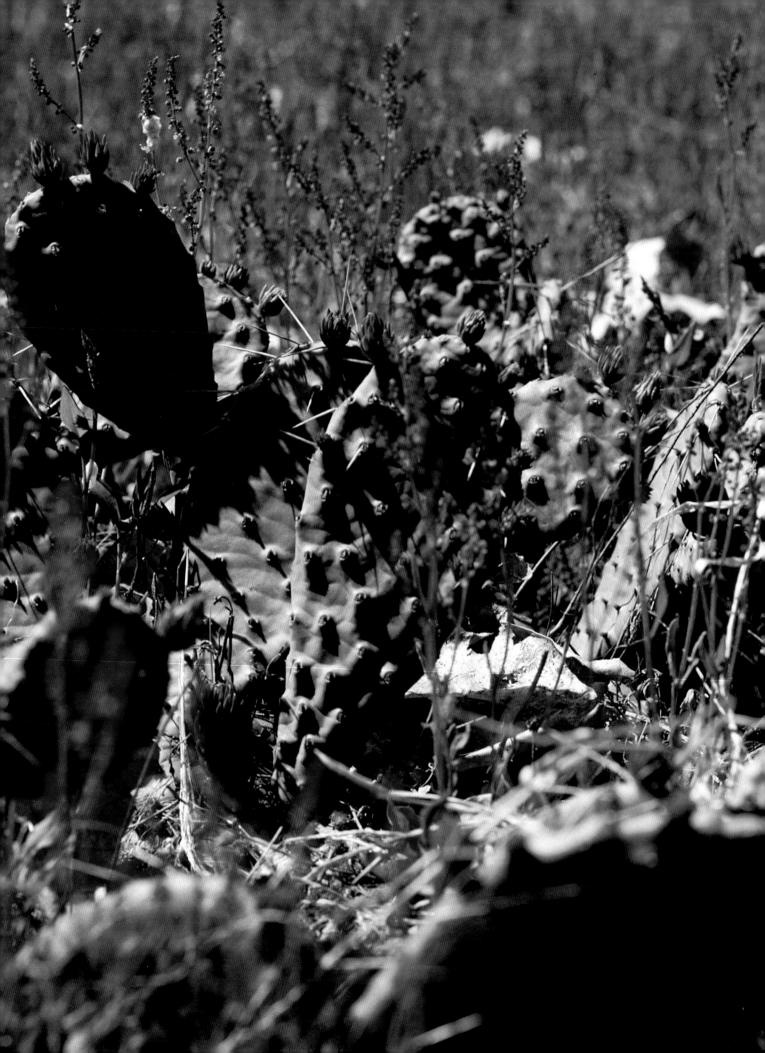

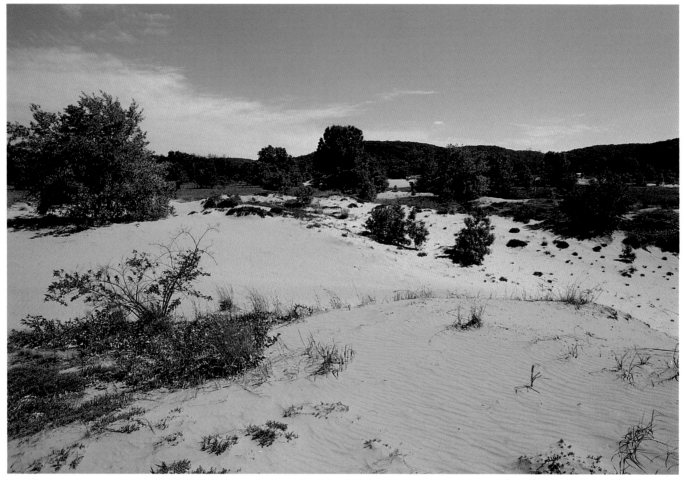

Blue River sands, Crawford County. Where waters roared past from Glacial Lake Wisconsin, sands eventually settled to make what some would call the "Wisconsin desert" in the lower reaches of the Wisconsin River just before its merger with the Mississippi River.

Photo by Robert Queen, Wisconsin DNR

Prickly pear cactus. This cactus may soak up the sun's energy in the day, but it dosen't open up for carbon dioxide until night. This approach conserves water and is needed where coarse sands lose rain water quickly. Silts, clays, and organic matter, such as old roots, can produce a soil water holding system that enables prairie grasses to survive. And in a dense prairie sod with tall grasses, the cactus would be a unsurped.

Photo by Robert Queen, Wisconsin DNR

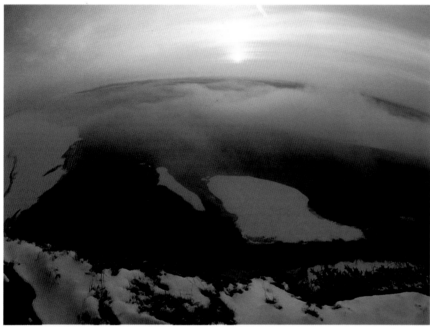

The two brothers who rowed passengers across the Wisconsin River at this location established the name "Ferry Bluff." Raptors, including the bald eagle and the rarely seen migrating golden eagle, draw naturalists to this area today.

Photo by Bruce Fritz

Surrounded by an open sky and fairly steep banks, the Wisconsin River, more than any other river in the state, holds a complex fish community. Included are species associated with the Muddy Missouri and Mighty Mississipi, plus those abundant in small headwater streams. Paddlefish and goldeneyes are two rare species in the Wisconsin that tie the fish community to the Great Plains' rivers.

Photo by Robert Queen, Wisconsin DNR

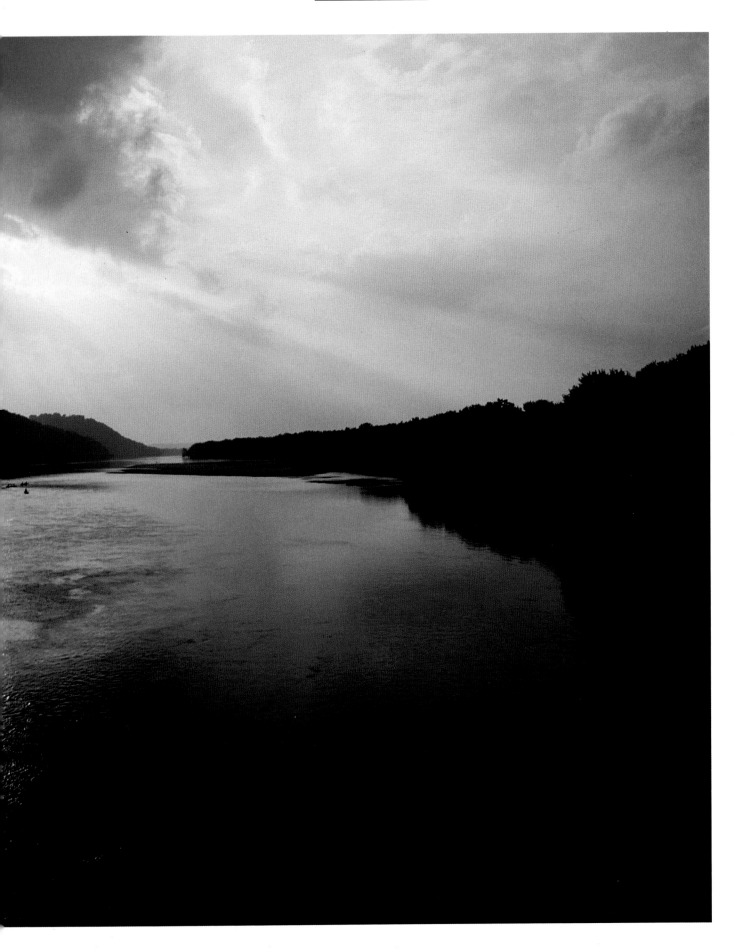

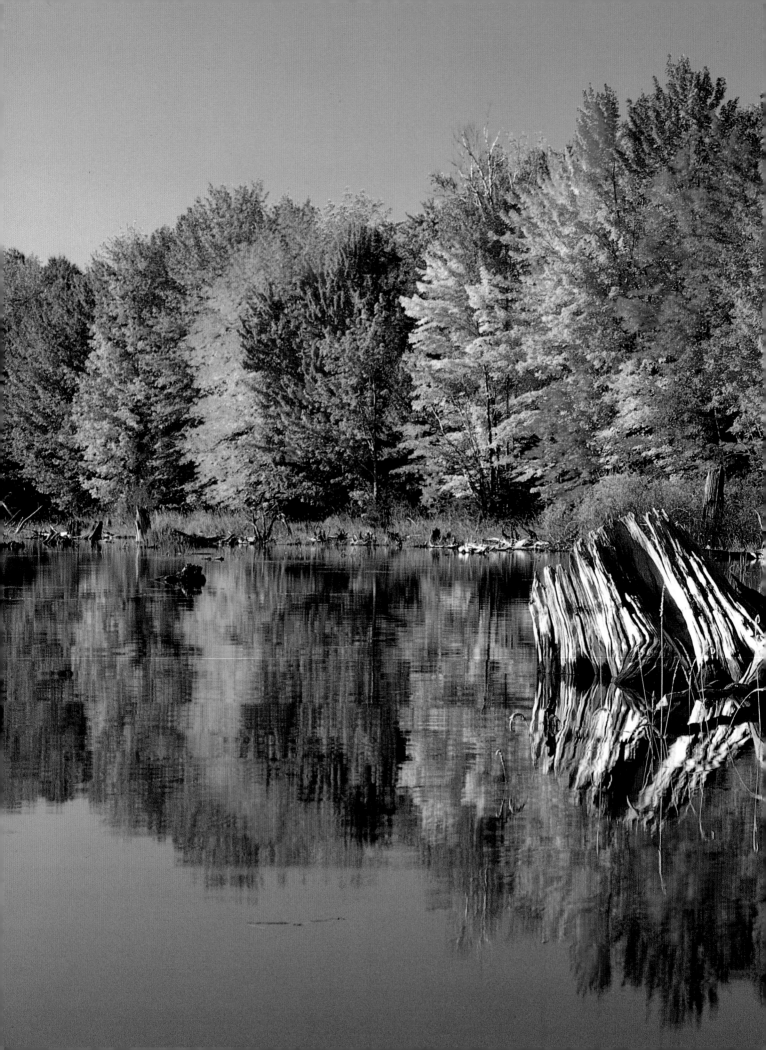

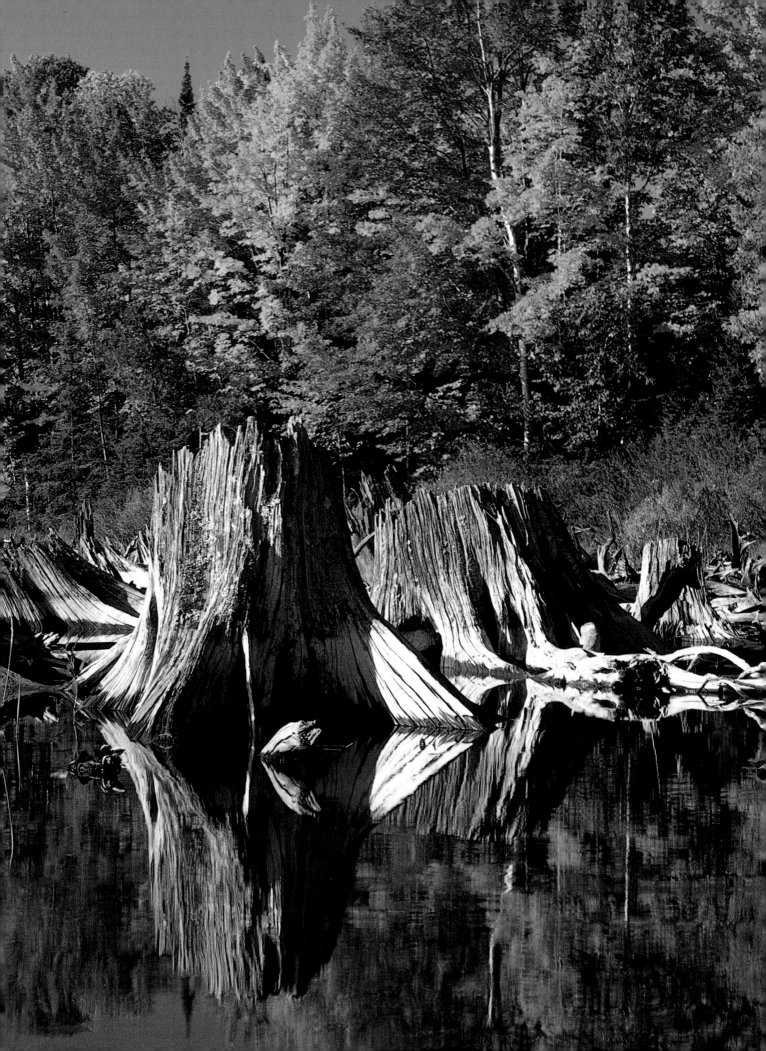

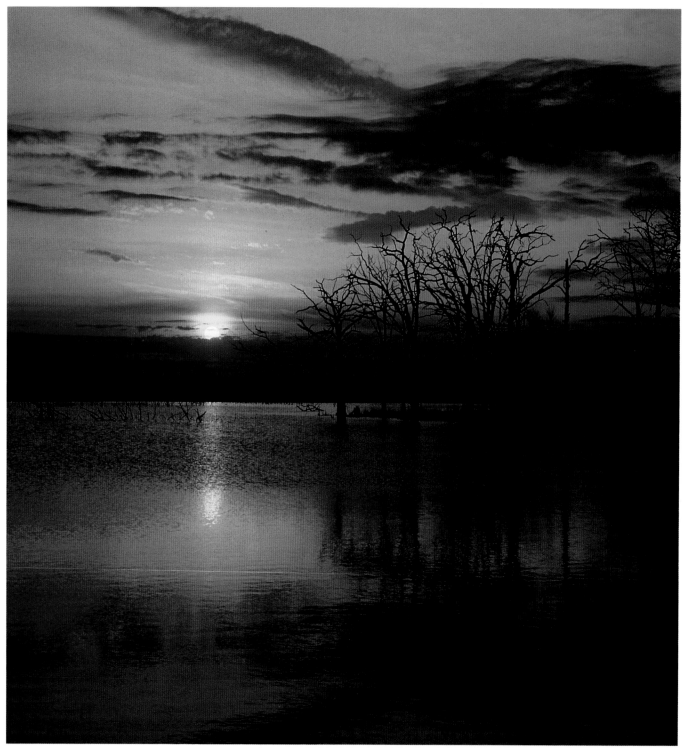

The Bong Recreation Area, Kenosha County. At an extreme, Bong represents wildness regained in Wisconsin. In an intensely used region of southeastern Wisconsin, this area is used for hunting, fishing and various other recreational pursuits through its ownership by the Wisconsin Department of Natural Resources. Just previous to that, it had been a U.S. Air Force base. *Photo by Mark Wallner*

(Overleaf)

Willow Flowage, Oneida County. Autumn is a time of risky weather, but autumn lakes seem to be free of the hustle and bustle of spring and summer. The fabulous colors and the tranquility make it worth risking bad weather to seek wild Wisconsin in the fall. *Photo by David L. Sladky*

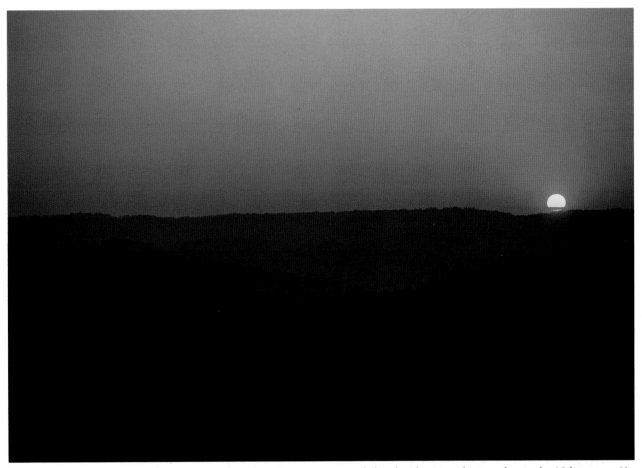

Blue Mounds State Park, Iowa County. The explorer, Jonathon Carver marveled at the Blue Mounds' vistas late in the 18th century. He would have seen fewer dense forests on the skyline then. In their stead would have been mostly oak savanna. A savanna exists when the trees, mostly oaks in Wisconsin, are spread far enough apart to let light and water reach grasses and other plants that have to reach towards the sky fresh each year.

Photo by David L. Sladky

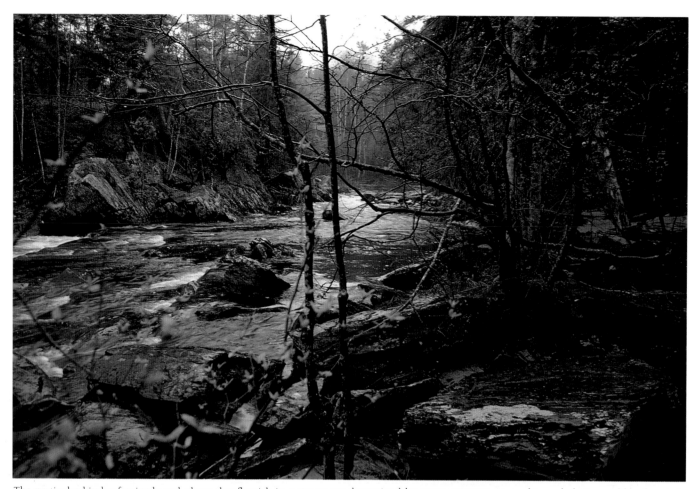

The particular kinds of animals and plants that flourish in a stream are determined by water temperature, quality and clarity, and by chemicals from the soils and rocks. That community is also affected by what types of trees line the banks and drop their leaves. The quaking aspen has soft leaves which are easily eaten and decomposed. Evergreens, such as the white spruce, shed needles which require long exposure to the fungi, bacteria, algae, and animals of a stream before breaking down.

Photo by John Rasmussen

Who else but the brilliant cardinal is willing to take the risk and begin territorial defense in late January if a bright and sunny day appears? Who else but the cardinal would think that mating season is ready to begin? Answer: The great-horned owl, that's whooo.

Photo by Ted Thousand

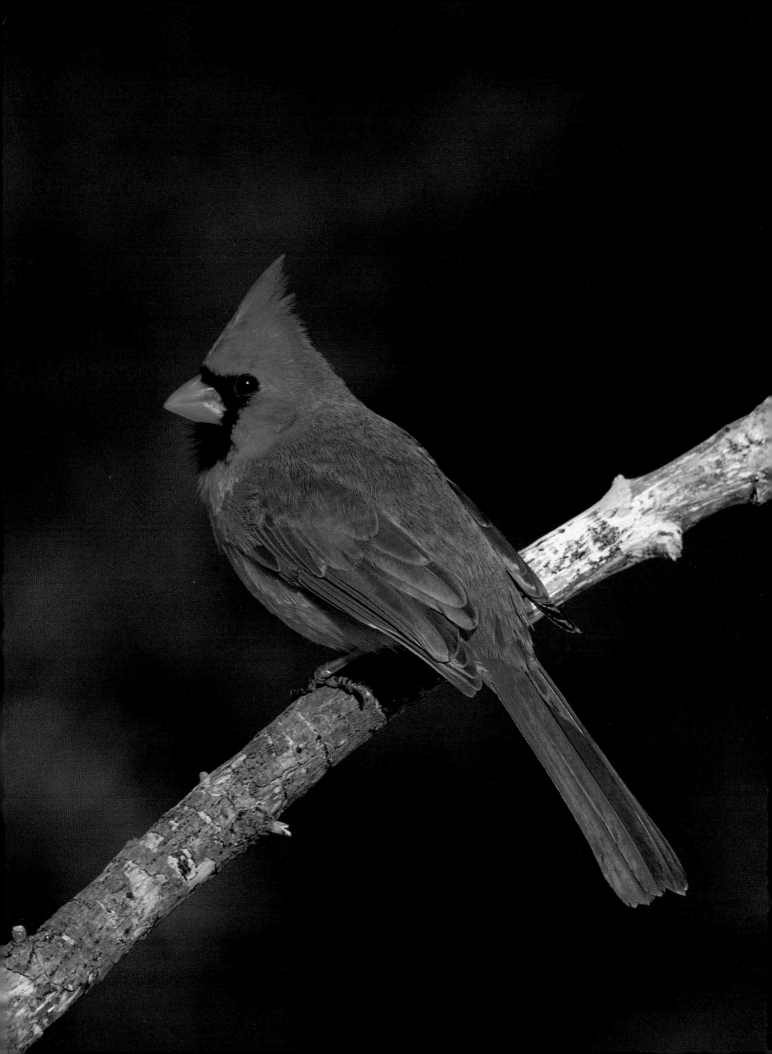

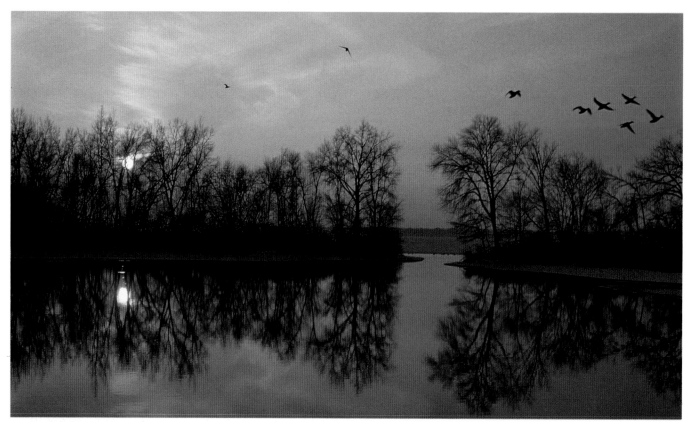

Wisconsin Glacier created many lakes, marshes and watersheds. The Yahara River eventually flows into the Rock River after passing through Lake Koshkonong. Migrating canvasback ducks used to stop here, but waterskiers and silt now spoil the space which once provided wild celery for the birds on their long flights.

Photo by Bruce Fritz

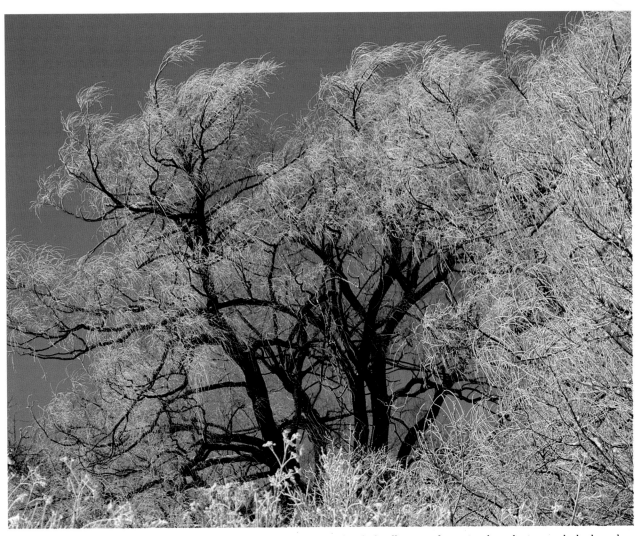

Blue Mounds State Park, Iowa County. A light frosting of ice and snow has little effect on a forest. Load on the ice, push the branches around with a strong wind and keep the temperatures below freezing and you have a recipe for ice-pruned forests. Ice storms may greatly alter branch patterns through the collapse of those of some tree species but not others. The ice storm influence may be noticeable decades later to a discerning eye. To a discerning woodpecker the ice storm damage may provide a useful larder of insects feeding on the damaged plants.

Photo by Robert Queen, Wisconsin DNR

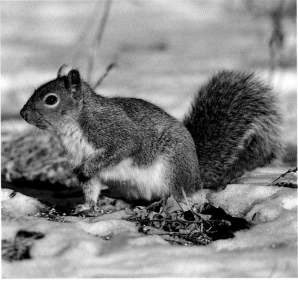

If we were asked what grey squirrels would like to eat, most would answer acorns and seeds. But mushrooms, baby birds, or indeed, the buds of sugar maple trees in the early spring? All are grey squirrel delectables. *Photo by Ted Thousand*

Some of the grandest tree shapes in Wisconsin are to be seen close to residences. Open-grown oaks with their sprawling branches drooping to the ground are very rare in the countryside, but look for them in suburbs established on former savanna or dry forest. With sufficient sunlight, some trees reestablish low branches even their middle age. *Photo by Bruce Fritz*

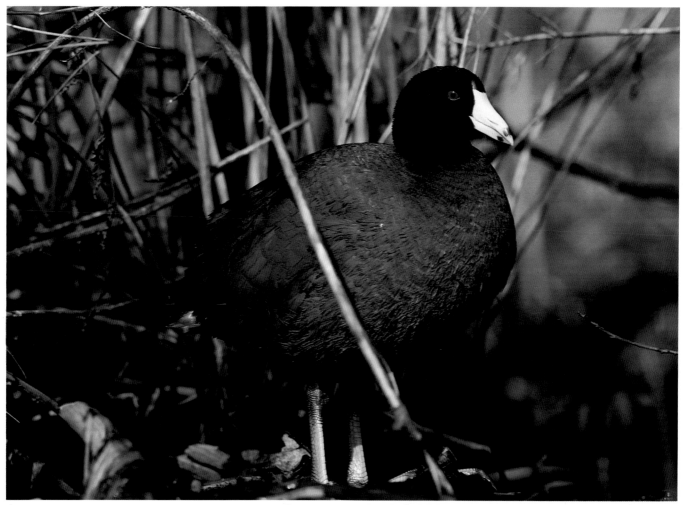

With a name like "marsh chicken" and a soft clucking sound, the American coot might seem to be a fancy barnyard chicken. But the habitat is quite different, and a coot on dry land would be a bird out of place. A Wisconsin marsh would seem out of place if it didn't contain a number of this common bird, especially during migration.

Photo by Dr. Scott Nielsen

Hiding is a cardinal necessity for most animals. Few are big enough or small and nasty enough to be boldly visible. Whether as predator or prey, the advantage most often goes to the animal who can avoid detection. The bull snake demonstrates its camouflage.

Photo by David L. Sladky

(Overleaf)

The plants of meadows in Wisconsin's "cut-over" lands are often as European in ethnic origin as the settlers and loggers who brought the species with them. Of course, the strong similarity between Wisconsin and northern European climates has made the transition easy for meadow grasses and introduced flowers.

Photo by David L. Sladky

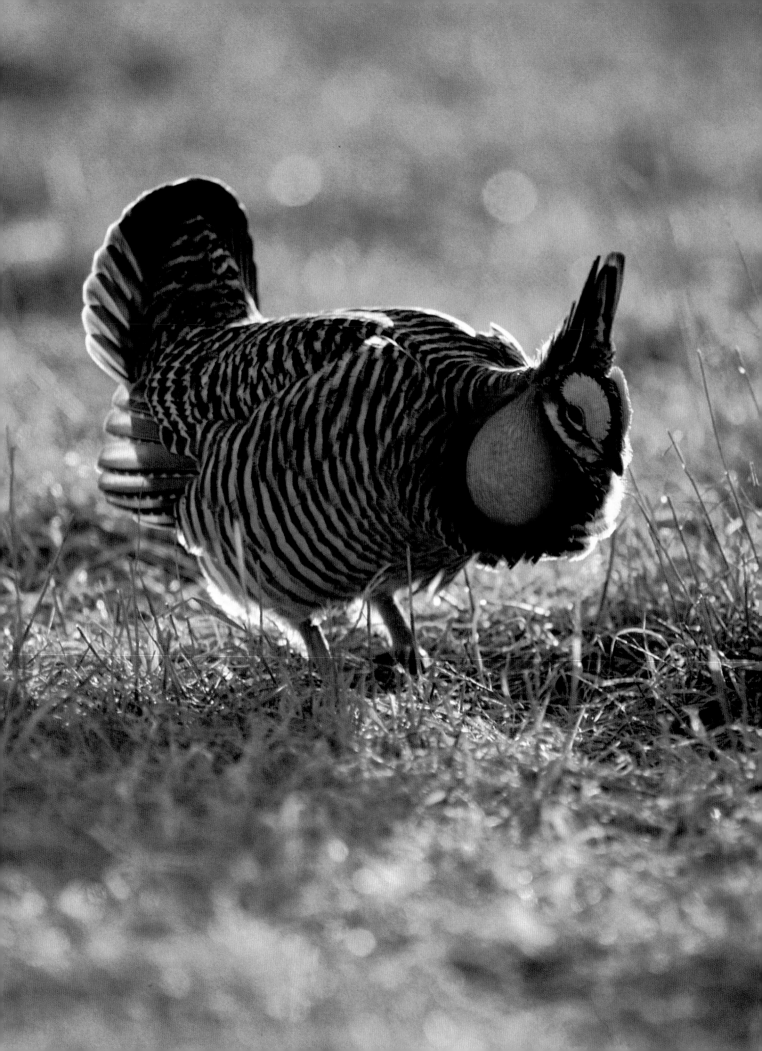

EAST FROM PORTAGE

Some divides were made to be crossed. The narrow separation between the Great Lakes waterway and the Mississippi River's vast watershed that occurs at Portage, Wisconsin, is a divide we will cross. From here we will stop paddling upriver from the Mississippi and start paddling downriver toward Green Bay and Lake Michigan.

If there was a strong flood surge on the Wisconsin River we could float across to the lower-lying Fox River through the streets and backyards of Portage. Instead we will have to take our canoe out at the Highway 33 bridge and begin the first part of our journey toward Green Bay on the sidewalk. While we're walking we can consider the significance of this place.

Portage began as a U. S. outpost on the frontier: Fort Winnebago. As the name suggests, native people were prominent here when the U. S. military forces arrived. The Ho-Chungra, or Winnebago, who spoke a language like that of the Dakota, were interspersed with Sac, Fox, Menominee and others. Their paths crossed, not always peaceably, in this part of the state long before the U. S. established dominion.

Different types of landscapes and natural communities also come together around Portage. Migrations and population expansions among these landscapes and communities make this an even more complex area. Near here the glacier stopped moving west. Two glacial lakes, Wisconsin and Oshkosh, existed close to one another separated by glacial moraines and ice dams. Prairie, wetland, oak savanna and deciduous forest habitats existed here but occasionally were altered by adjacent communities.

Heading overland to the east, we come upon the headwaters of the Rock River, which flows south, and to the southeast of that, another Fox River. This Fox River originates from a hardwater spring in the Kettle Moraine, an area squeezed between two glaciers. It also flows south, passing through relatively narrow marshes on its way to Illinois.

To the south, where the Wisconsin River sweeps around the east end of the Baraboo Hills, numerous drumlins fan out northeast to southwest. Tamarack swamps are common in the wet intervals between the tear-drop shaped drumlins. Hardwood forests that developed from oak savannas are frequent on the drumlin ridgetops.

Just a short distance to the west lie the terminal moraines that separate the scoured landscape and the occasional glacial lake bed from the gently sloping

Prairie chicken, Mead Wildlife Area. Reflecting the settler's advance into the cleared forests of Wisconsin, this bird also settled in all parts of the state. Although settlers could persist with their farming in the face of a forest invasion of marginal lands, the prairie chickens could not sustain their populations. So these animals, often called "boomers", hold out only in a few relic populations in central Wisconsin where management with fire and pasturage hold the relentless trees at bay, and where croplands are scattered and not continuous. *Photo by Robert W. Baldwin*

sandstone and dolomite rock formations of the unglaciated area of the state. A road map shows the contrast. Southwest of the glacier, roads twist and turn with the topography, while in the central part of the state lengths of straight north-south and east-west roads meet at predictable right angles.

To the northwest is the level expanse of the bed of Glacial Lake Wisconsin. This area of marshes, irrigated farms and planted pine stands is punctuated by islands of white pine on sedimentary rock buttes. There are also sand dunes which started out as beaches or river deltas. It is in this area that a few prairie chickens still boom and the sandhill crane is a common bird of the fields and meadows.

Having considered the many faces of wild Wisconsin that meet at Portage, we head down the Fox River toward Green Bay.

As we move on, we jump five deer from the bottoms. They bounce up toward higher country. Just 30 or so years ago, whitetails were rare in the southern part of the state. Deer hunters went "up north" to the big woods. In counties like Dane, the sighting of a deer was a big local event. Now whitetails are abundant throughout southern Wisconsin. They have adapted well to the mix of forest and field. In fact, throughout the state, deer are far more abundant in a relatively tame Wisconsin than they were in pre-settlement Wisconsin when it was really wild. Unbroken forests did not provide the food resources to support large numbers of deer. Eating between six and eight pounds of leaves, twigs, buds and bark per day, deer thrive only in productive habitats. The original northwoods was actually better suited to larger members of the deer family—moose and woodland caribou.

Watching the deer disappear into the woods, we were impressed, even humbled, by their grace and power. Whitetails can bound nearly 10 feet from a standstill. Over their centuries of coexistence with wolves, cougars and other predators, whitetails have developed effective escape maneuvers. Their evolution also provided adaptations to help survive the rugged winters that still visit northern Wisconsin every decade or so. When the temperature drops, so does the whitetail's metabolism. With a thick layer of fat put on in the late summer and early fall, whitetails can handle all but the severest winters.

The deer, secure in the depths of the brushy uplands, go back to their daily habits. They are just five out of a herd estimated at over one million animals. Countless times every day, canoeists, cyclists, birders, farmers or anyone else outdoors is stopped cold by the sight of a bounding whitetail. The experience is an important part of wild Wisconsin.

We travel through some of the largest sedge meadows that persist in Wisconsin. Parts of other natural communities exist within these expansive meadows.

At a distance it may appear to be a sea of grass surrounding these islands of oak forests or pines, but sedges are not grasses despite the similarity in appearance. The frequent triangular shape of the stem and leaves plus their tolerance of standing water and soil zones with little oxygen distinguishes them from most prairie grasses.

There are islands of prairie in the headwaters region of the Fox, though. The richness of the flowering display needs to be regained by fires and a decrease in deer. Even so, we can see yellow puccoon, blue lupine and the pink-purple of the sticky geranium in season.

Some of the drab grassland sparrows, birds that are more often heard than seen, still sustain themselves here amidst the sedges and clumps of grasses. Clay-colored sparrows and Henslow's sparrows hang onto existence here as their habitat in Wisconsin and the Midwest is threatened by tree expansion, frequent hay cutting

and cats. (Cats kill several million songbirds across the state each year. Eastern meadowlarks, vesper sparrows, bobolinks and dickcissels are some other upland bird species especially vulnerable to cats.)

It's hard to think of grasslands and sedge meadows as we venture into the big open waters where the Fox meets the Wolf River, and both flow into Lake Winnebago. Here a few scattered bulrush and cattail clumps testify to emergent aquatic communities that were recently expansive and productive, but are now declining. If resource management is successful in regaining the diversity of plants on these waters, they may again support the rafts of canvasback ducks that used to refuel here on the wild celery beds that grew in the shallow water.

Wild Wisconsin in this area has to deal with industrial Wisconsin and even recreational Wisconsin. As with the emergent aquatic plants mentioned above, pollution, boat traffic and controlled water levels take their toll. But ironies abound. Consider the sturgeon in the lake water below us. Each year in the late winter a spearing season on Lake Winnebago yields some of the oldest nonhuman animals that live in Wisconsin. Sturgeon may be more than a decade old before they ascend the Wolf River to spawn for the first time. The fact that the downstream locks and dams restrict the alien sea lamprey from Lake Winnebago benefits sturgeon, although the same dams have negative effects on streamside marshes. Sea lampreys have become a concern only because the once highly toxic lower Fox River waters have been cleaned up due to millions of dollars spent on industrial and municipal sewage treatment facilities. It demonstrates the difficulty of re-establishing a natural order once it has been lost.

Were we to detour and paddle up the Wolf River like lake sturgeon running to spawn, we would come upon one of the finest forests in Wisconsin. Owned and managed by the Menominee along both sides of the Wolf, this forest escaped the intense cutting of the late 1800's, as well as the fires fueled by slash that followed. This forest is exemplary in the quality of its ground cover vegetation. A white-tailed deer herd that would decimate these plants has never developed because the Menominee people "make meat" from the deer. Logging occurs here in a manner that sustains quality. If this is an exploration you choose to make, be sure to secure permission appropriate to any private property.

However, we will keep traveling downstream on the Fox to Green Bay. Rock outcrops and, occasionally, good fishing spots may be found. Once on Green Bay it may be prudent to trade in the canoe for a larger craft. Then our explorations can take us to the state parks and wildlife refuges of Door County to the northeast or along the Green Bay marshes to the north. Again we have choices for finding wildness in Wisconsin.

Within the jumbled terrain of the Kettle Moraine many small streams flow from hard water springs. Some of the springs are covered with vegetation that can tolerate the unusual chemical baths from what are called *calcareous fens*. The fens may even occur right at the edge of streams to give a canoeist a yellow warbler's perspective on grass of Parnassus and other fen loving plants.

Photo by Robert Queen, Wisconsin DNR

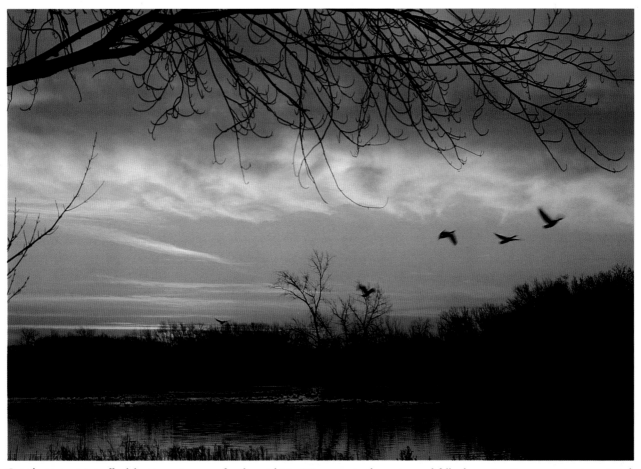

Canada geese rising off a lake at sunrise are a familiar sight in Wisconsin in the spring and fall when migrating geese stop to rest and feed. They are almost as familiar a sight in farm fields gleaning what they can in this adaptation to a changing habitat.

Photo by Darryl R. Beers

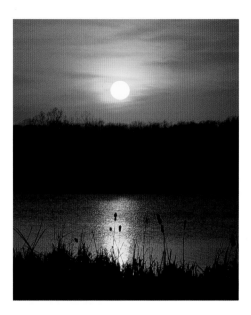

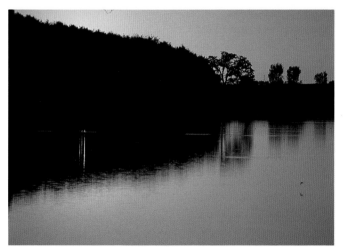

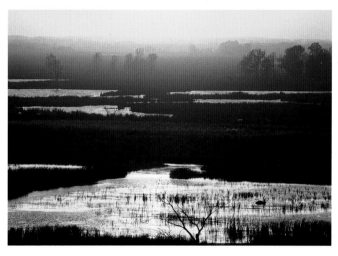

(Top)

Cherokee Marsh, Dane County. The lakes of Wisconsin were larger and more numerous in the recent geologic past. Open water gave way to bulrushes, cattails, and later sedges as lake after lake was transformed into wetland. Marshes in Wisconsin still cover tens of thousands of acres in total and are the largest open habitats remaining in the state. Sandhill cranes have recovered from low populations in the first third of this century because, in large measure, treeless marshes provided remote places in which to rear young. Bereft of trees the marshes can be surveyed for predators by wary cranes and can also be flown across with ease. *Photo by Robert Queen, Wisconsin DNR*

(Above left)

Goose Pond, Columbia County. The still waters of a pond at sunset provide a modern explorer with a dynamic visual world. Blues in the sky fade, while reds and yellows intensify briefly. If one's eyes are given the chance to adapt, trees, rocks and other prominent objects are visible long after the casual viewer would have turned on the flashlight. *Photo by Robert Queen, Wisconsin DNR*

(Above right)

Horicon Marsh, Dodge County. The marsh scene which ends in ditch banks with trees is largely an historic artifact in Wisconsin's protected wetlands. Aggressive drainage schemes were planned and implemented for all significant Wisconsin wetlands. Lack of capital and a surplus of agricultural commodities kept some of the schemes from succeeding, but the landscape's scar remains. Within the ditch bank tree lines, white-tailed deer and other large species find hideaways that are security from the open uplands so common in heavily farmed parts of the state.

Photo by Bruce Fritz

(Left)

The waters and soils of the marsh are soon to be seeded with a multitude of cattail seeds. If the winds are strong when shattering occurs, the seeds may travel for great distances, but most land on unfavorable terrain and do not grow. *Photo by Dr. Scott Nielsen*

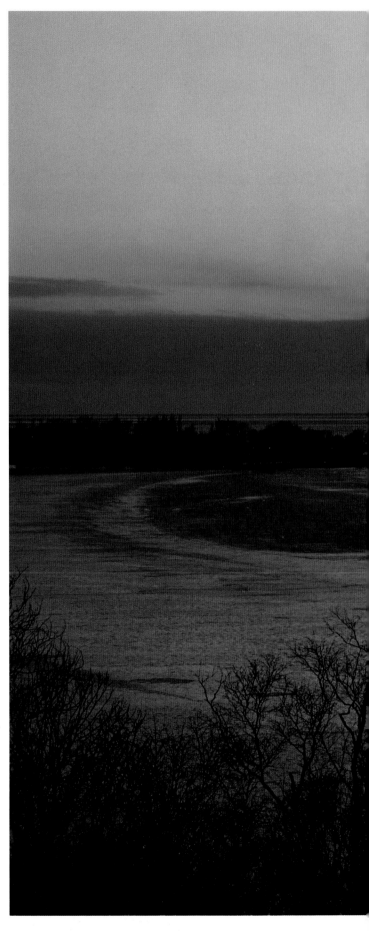

Parfrey's Glen, Sauk County. Streams of ice with their silvery cliffs remind us that winter is a time of stasis for much of wild Wisconsin. Short days of numbing cold require more energy than many plants and animals have to spend. Even swiftly flowing streams may succumb.

Photo by Bruce Fritz

The west side of the Door County peninsula has two contrasts to the nearby east coast: brilliant sunsets and heights from which to view them.

Photo by Darryl Beers

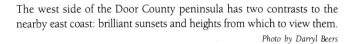

(Overleaf)

Green Bay, Door County. A sunset over snow and ice pack shows pressure ridges or wave splash ridges of ice near the shore. A big body of water rarely freezes quickly, and is swept by breezes and winds that turn spray to ice which records the last motion before the waters are frozen in place.

Photo by Darryl R. Beers

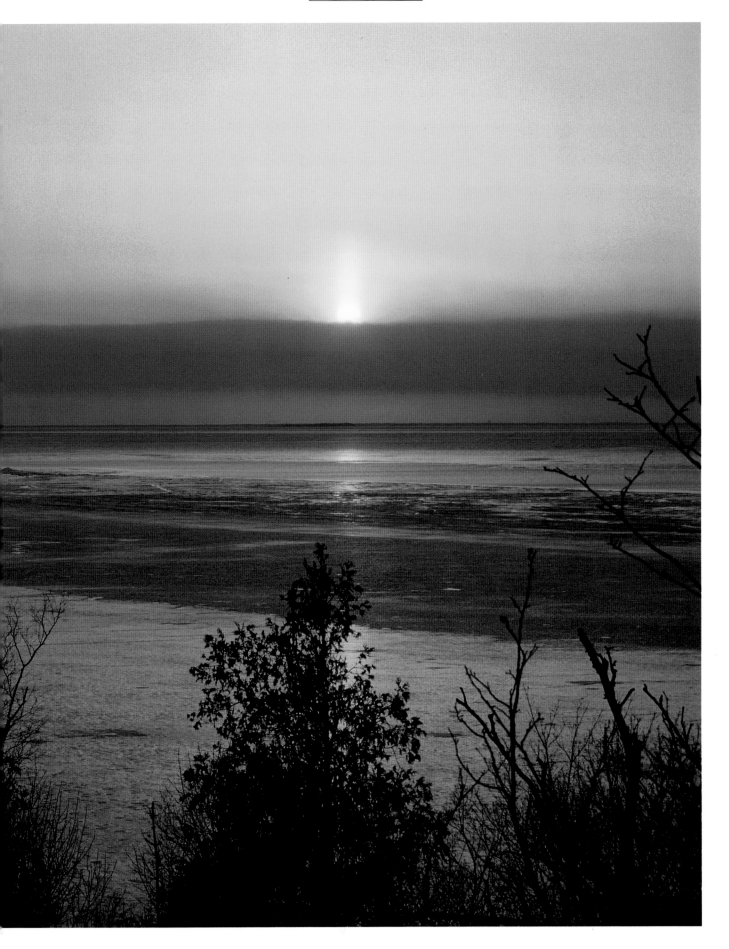

Newport State Park, Door County. Lake Michigan is marked by the rhythmic seiche which causes the lake and its low-lying tributaries and wetlands to rise and fall 13 times each day. The pulsing action is due to atmospheric pressure changes and winds over the length of the lake. Despite the occasional disrupting storm, this seiche establishes a smooth rhythm. In your canoe, try riding it into Rowley's Bay on a calm day. Wait a bit and ride it back out.

Photo by Robert Queen, Wisconsin DNR

The Niagara Escarpment is a rock formation that stretches from Iowa to New York. In Wisconsin, this dolomite formation is the sturdy base of Door and Kewaunee Counties in the northeast, as well as much of Grant County in the southwest. In the east, it ends dramatically at Niagara Falls.

Photo by Darryl R. Beers

If they were not overbrowsed by snowshoe hare or desperately hungry white-tailed deer, white birch and balsam fir grew quickly after logging or severe fires removed the more shade-tolerant and longer-lived trees dominant in the ancestral forest.
Photo by Carol Christensen

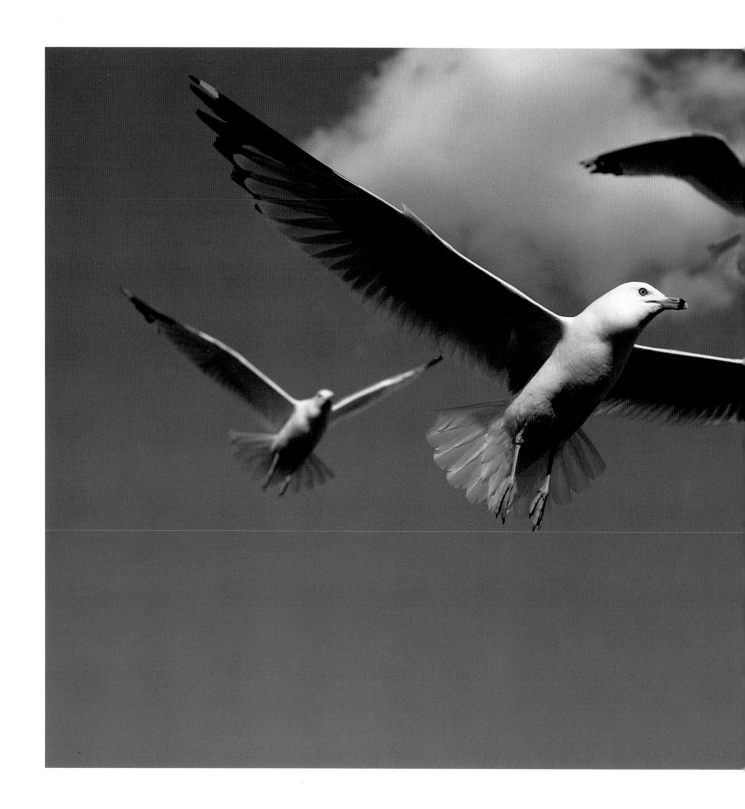

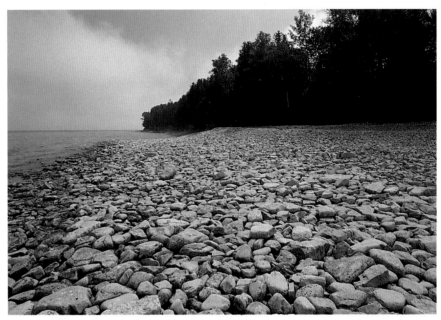

Rock Island State Park, Door County. The cobble beach of Lake Michigan's northwestern shore shelters sculpins. Sculpins are small fish with large heads and this species adapted to beach life with features that enable them to resist even severe waves, they can do well in the rushing waters of rapids, too. *Photo by Robert Queen, Wisconsin DNR*

Visitors to many parts of Wisconsin enjoy the raucous company of gulls such as these ring-necks. And what better complement to a day spent strolling the wharves of Door County or sailing along a sandy Superior beach? *Photo by Dr. Scott Nielsen*

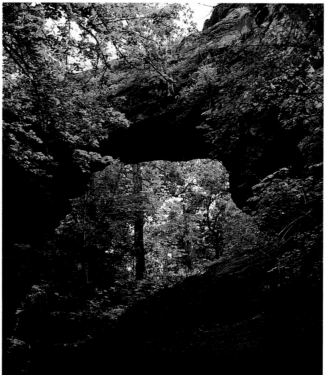

(Top)

Botanists would urge rock climbers to find other practice areas than those still inhabited by relic plants such as the blue colored northern monkshood. Nearby Devil's Lake State Park would be a good place to test climbing skills.　　　　*Photo by Robert Queen, Wisconsin DNR*

Natural Bridge, Sauk County. The wild treasures of Wisconsin include rock formations we might associate only with a desert landscape. The sandstones and conglomerate rocks which rest on top of the hard Baraboo quartzite may be eroded to produce arches.

Photo by Gregory K. Scott

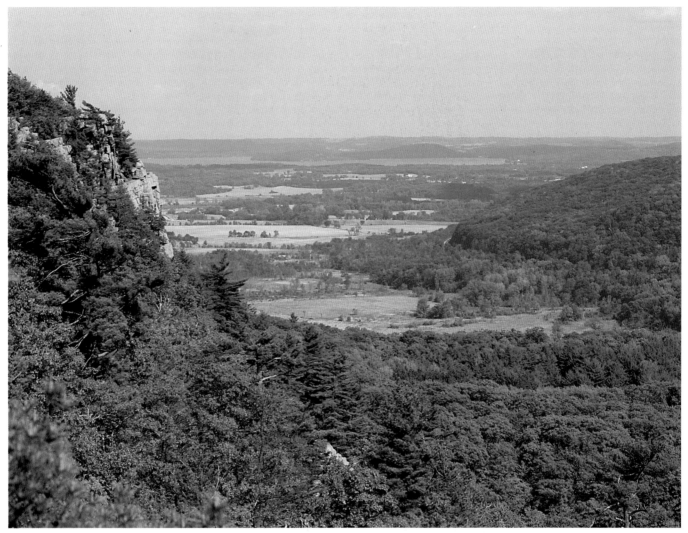

Devil's Lake State Park, Sauk County. Glacial Lake Wisconsin stretched out of sight to the north from even the highest cliff at what is now Devil's Lake State Park. The Green Bay lobe of the Wisconsin Glacier pushed gravel and ice into a moraine that trapped ice and water to form Devil's Lake, now one of Wisconsin's most popular vacation camping spots.

Photo by Allen Ruid

(Overleaf)

The windy savannas which rolled tall grasses and wildflowers in waves over fertile black soil were noted for sprawling oaks. Most often, these were bur oaks if the soil was of really good quality. Livestock, plows with moldboards, and shade from unhindered trees brushed the savanna out of Wisconsin's history before the first settler's children reached their own maturity. A single oak in a pasture signals the absence of 199 other native species that may have kept it company in a natural savanna.

Photo by Darryl R. Beers

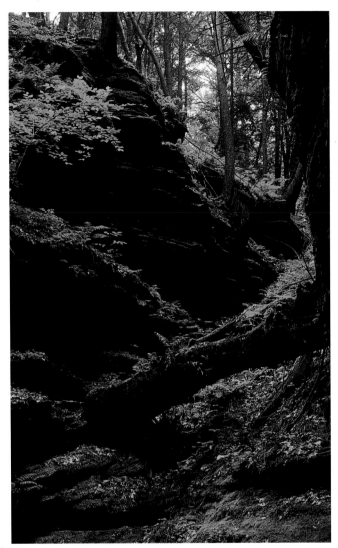

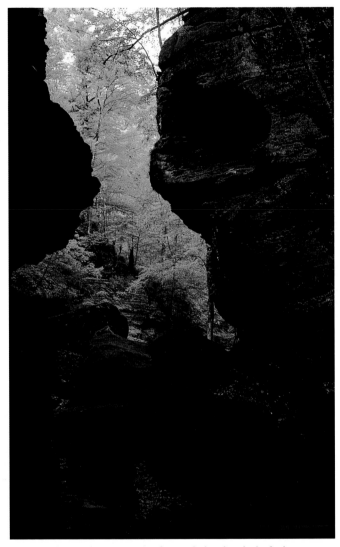

Wisconsin Dells, Adams County. Where the glaciers were in Wisconsin is fairly obvious. But where they influenced the geologic features without their actual presence is less easily discovered. After centuries of gradual retreat from its most westerly advance, the Green Bay Lobe melted quickly and meltwaters accumulated behind a dam of ice and gravel. Thus Glacial Lake Wisconsin reached its highest levels. An abrupt bursting of this dam which was located south of Portage resulted in a dramatic and massive draining to the southeast. Wisconsin Dells was formed as the sedimentary rock was scoured by the thunderous outpouring of water in a period of a few months or less.

Photo by Mark S. Werner

Parfrey's Glen, Sauk County. Conifers, including hemlocks find root space in cracks amidst even the hardest rocks. These trees, if they survive, can cause the cracks to deepen and widen and become better homes to the tree roots. The steep cliffs provide security for seedlings as well. The security is from the chainsaw of the logger who calculates net return on time invested and leaves the cliff-dwelling trees alone.

Photo by Gregory K. Scott

Parfrey's Glen, Sauk County. Narrow ravines channel cold air and keep cliff faces cool. This suits the threatened northern monkshood. Ice "waterfalls" form in winter and add an additional "Ice Age" aspect to the benefit of plants and animals, many of which are relics of the actual Wisconsin Ice Age thousands of years ago. *Photo by Gregory K. Scott*

Wisconsin Dells, Sauk County. The steep banks of sandstone at the Wisconsin Dells support noteworthy plants that may customarily be common only in much colder regions. The long period of interest in the natural history of the Wisconsin Dells area has left few plants unidentified.

Photo by Mark S. Werner

Within a decaying log, ants, beetles and numerous other insects feed on the micro-organisms that are able to convert cellulose and lignin to soil. Trees support life long after they have ceased to live; first as dead standing trees - home to insects, birds and mammals - and later as decaying logs. They may fill this role in death and decay for nearly as long as they lived.

Photo by David L. Sladky

(Overleaf)

Eau Claire Dells, Eau Claire County. The name of this falls reflects both the French and English heritage of Wisconsin. Eau Claire means "clear water" and "dells" is an English adaptation of the French word *dalles* which means "the narrows of a river" or "between the cliffs." In any language, it's a lovely place.

Photo by David L. Sladky

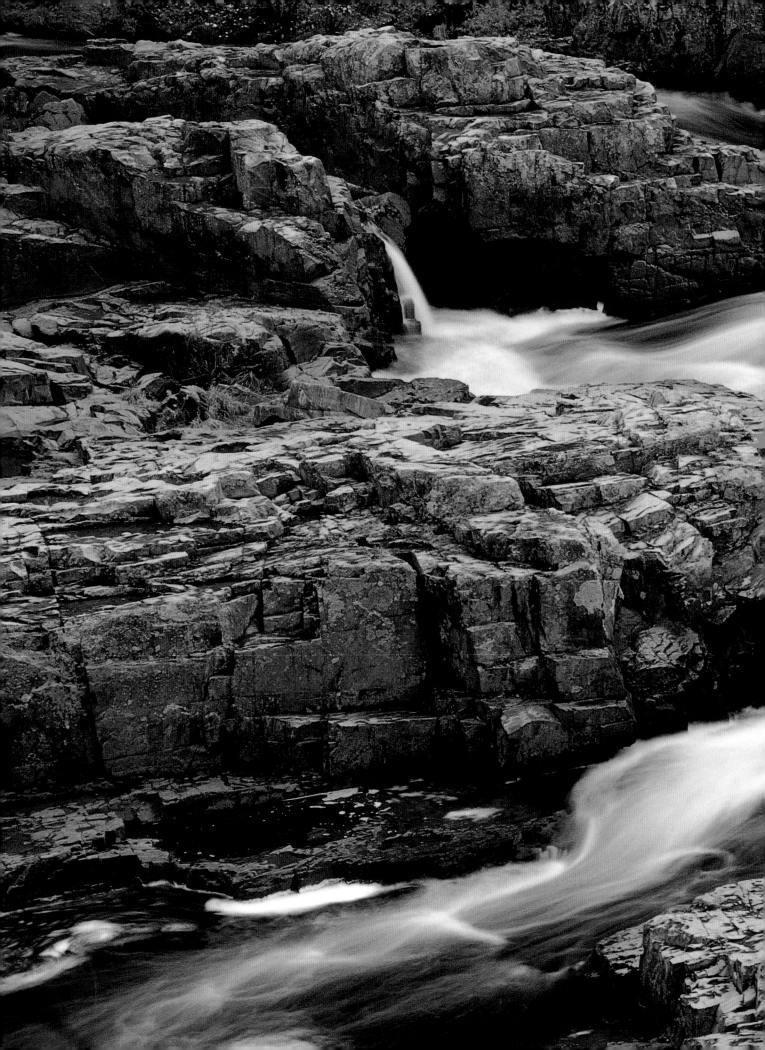

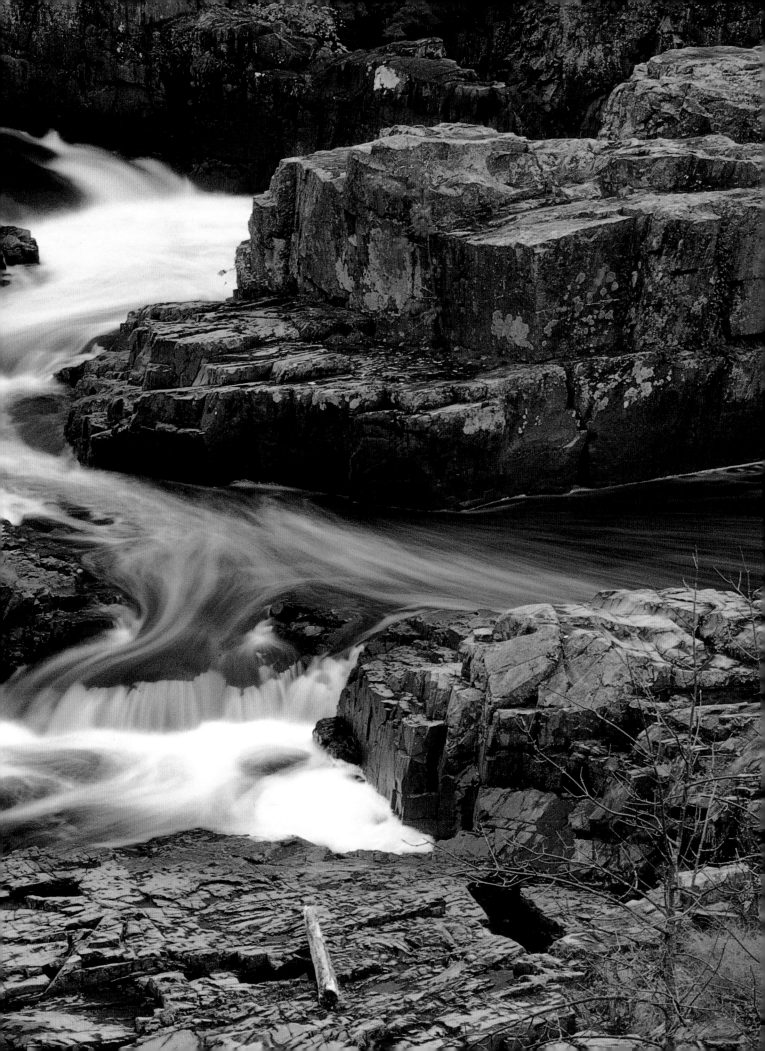

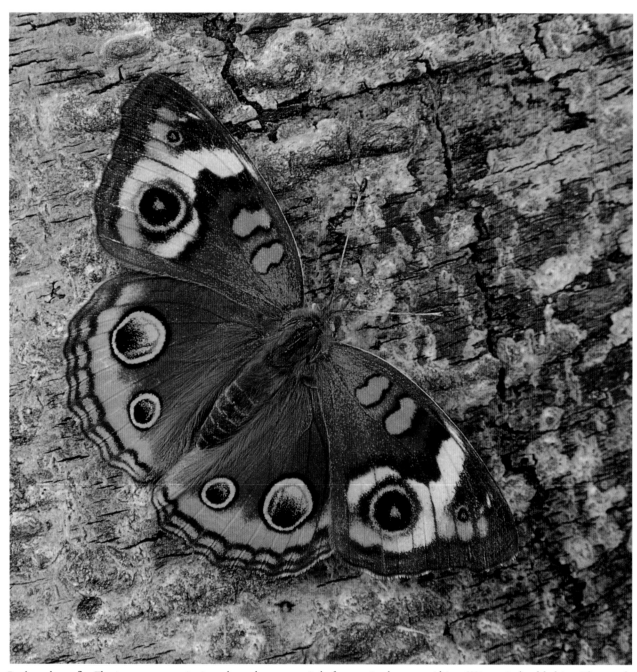

Buckeye butterfly. The insect community is perhaps the most varied of any animal group within a Wisconsin land habitat. Thousands of different species could be expected even within a 40 acre woodlot. Butterflies have distinctly different activities during their major mobile stages: caterpillars feed on leaves and winged adults feed on nectar and other plant exudations that have food value. The wings and the rapid movement attract unwanted attention that occasionally can be countered by effective camouflage. *Photo by Barbara Gerlach*

WEST FROM NIAGARA

Heading into the sunset is a long standing tradition. There are only a few Wisconsin rivers on which that can be accomplished. Most head south toward the Mississippi's outlet. They quite disregard human whimsy. But in northeastern Wisconsin, river sunsets can be found. Paddle and pole upstream on the Pine River above its confluence with the Menominee River and you will be heading west into the heart of Wisconsin's northern forest area.

We should note in passing that both the name and the location of the Menominee River recall the Native Americans for which it was named. They take their tribal name from the aquatic grass we call wild rice. The French who made the first white contact with the Menominee were struck by their dependence on and utilization of wild rice which is still grown and harvested in Wisconsin.

Up the Pine River we go. At first there is slack water from Menominee River flowages and a very gentle gradient. This extreme northeastern corner of Wisconsin was a pine barrens habitat. A small group, too small to be designated a flock any longer, of sharp-tailed grouse move around the remnant barrens here.

If a substantial breadth of public land is our goal, the Pine River can take us to the Nicolet National Forest, one of the few federally designated wilderness areas in Wisconsin. As we would expect of a wilderness area, it's home to a wide variety of animals, including the black bear, Wisconsin's largest mammal.

Not many of us ever see black bears, although there are over 5,000 scattered around the northern half of the state. Primarily nocturnal, they move in the fringes of the light, making them even more mysterious and interesting.

Bears and people actually have a lot in common. The track of a bear and a human footprint are quite similar. Bears can stand tall on their hind legs. They eat about the same kind of food we do, although they are less picky. And, the bear's body is put together very much like ours. For some, seeing a bear carcass without the hide is a fascinating but frightening experience. Some hunters draw the line at shooting bears because they are so much like us.

Probably humans are a bit jealous. When a bear's problems start to mount, when the food gets scarce and the weather nasty, the black bear just crawls into a makeshift den and sleeps for six or seven months. Now that's a retreat. To get ready for the big sleep they gorge themselves for weeks, eating up to 20 pounds of food a day to add about 100 pounds of insulating fat. Over their winter nap they lose 30 percent of their total body weight. Everything seems so easy. The females give birth to their cubs during hibernation.

To many Indian tribes the black bear is a powerful totem, a creature of wisdom and power. Few animals in North America have been honored with as much ritual attention. The "miracle" of hibernation stimulated much of this interest. The wildlife heritage represented by the black bear has been important for hundreds, even thousands, of years and continues today in wild Wisconsin.

WILD WISCONSIN

In the Pine River region the fisher has been re-established on the forest lands. This dark-colored weasel resembles a compact version of the wolverine and despite its name, it doesn't catch fish very often. Its preferred diet consists of porcupines and berries. While loss of habitat contributed to its brief absence in the state, trapping was the main reason it was extirpated. Like the pine marten, which has also been successfully reintroduced, habitat preservation is the key to retaining these species, and human commitment is the key to that. Trees planted in plowed logging debris are counted by the thousands, but tree plantations are not a forest. Fishers and pine martens need forests in all their complexity, and it will be humans who preserve this aspect of wild Wisconsin.

Unlike the landscapes near Portage, the northwoods in the late 1900's does not have much open area except where recent clearcuts or dairy farms persist. Mostly covered with midsuccession forest, there is a constancy to the nature of the habitat unlike that of anywhere else in Wisconsin. It's a significant component of the richness of wild Wisconsin. Although we have been traveling on rivers, we cannot leave this area of Wisconsin without mentioning the lakes and two bird species that never fail to stir the soul of visitors to the northwoods: eagles and loons.

This is eagle country. When you see a mature eagle, you know it. There's no squinting or rifling through bird identification guides. The brilliant white head and tail just shout eagle. They fly effortlessly, drifting from one column of upwelling air to the next.

There have always been eagles in Wisconsin to instill awe in those who long to fly so free, but they have lived through some hard times. Our country's national emblem was harassed and shot at for decades. Then DDT, a powerful pesticide that caused thinning of eagle eggshells, almost did eagles in. Thanks to crusading environmentalists, DDT was banned in 1972 throughout the United States, and eagle populations rebounded quickly. Now the sight of this master aerialist slicing through the northern sky is a regular feature of a vacation in northern Wisconsin.

In 1972, when the state placed the eagle on the state's Endangered Species List, fewer than 100 territories were being maintained with about 100 young produced each year. Now over 400 territories have been identified, and 450 eaglets are hatched every year, the majority in northeast Wisconsin. The eagle has returned in a big way to soar in the sunlight over the lakes of wild Wisconsin.

Sunset may be the best time to hear the haunting call of the loon. This magical bird has become an icon of the north. Distinguished by the startling checkerboard of its breeding plumage, by its fantastic display when alarmed and by its amazing vocal talents, there is little common about Gavia immer, the common loon.

You don't have to see one to appreciate its unusual character. Just listen. At sunset as the day quiets, let your boat drift. Forget time and open your mind to the most exquisite wilderness music you'll ever hear.

The formal part of the northwoods concert will open with a tremolo, a rapidly rising and falling call which shivers across a quiet lake. Blending with the tremolo will be the familiar mournful wail. These sounds often become stereophonic or quadraphonic as other loons join in, creating a choral effect complete with well-orchestrated harmonies. Why such a range of sound? No doubt biologists will argue about this for years, citing territorial defense, survival techniques, habituation and the like. The rest of us, though, can just lean back and enjoy the music. Thanks

to efforts of volunteer groups like Project Loon Watch, and to vigilant protection programs by the state, several thousand loons still perform nightly in the far north. Eagles and Loons provide the sight and sound of authentic wilderness. Their presence is a indication of the health of wild Wisconsin. We need to push on. We could attempt the "portage" from the Pine River to the headwaters of the Wisconsin River. But that would take days instead of the few hours it took to accomplish the watershed crossing at Portage. Besides, it would leave part of the state unexplored, another small watershed untraveled and another divide uncrossed. Through the magic of poetic license we will take flight with all our gear and splash down in Lake Superior at the mouth of the Brule River.

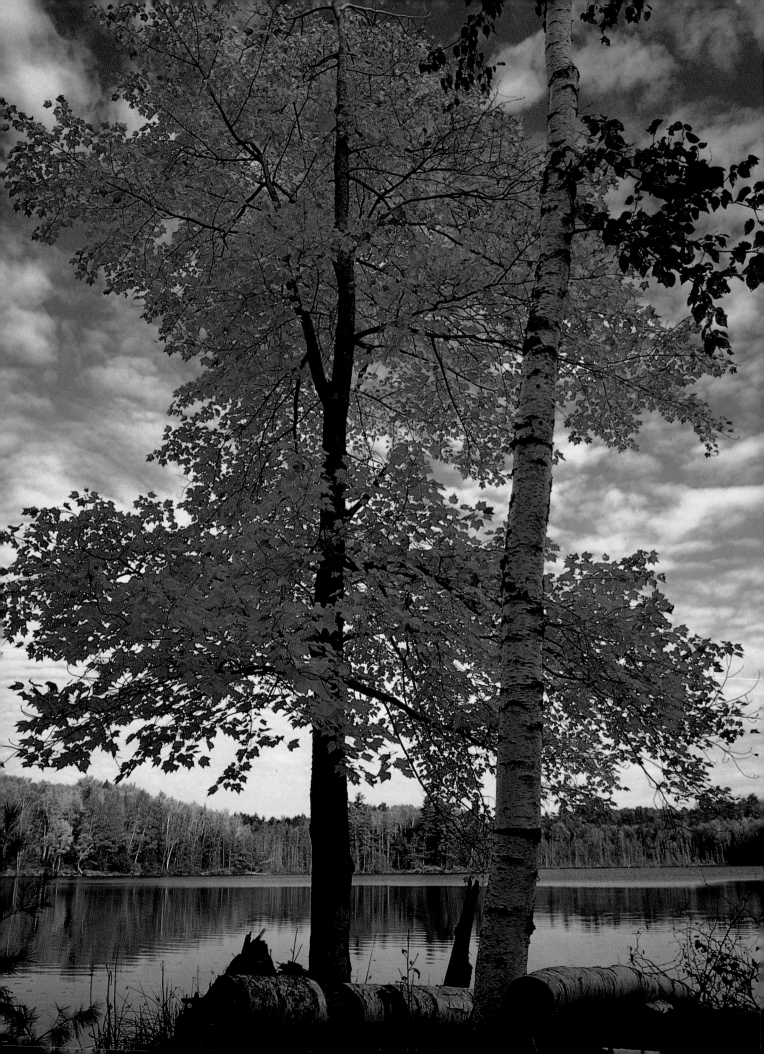

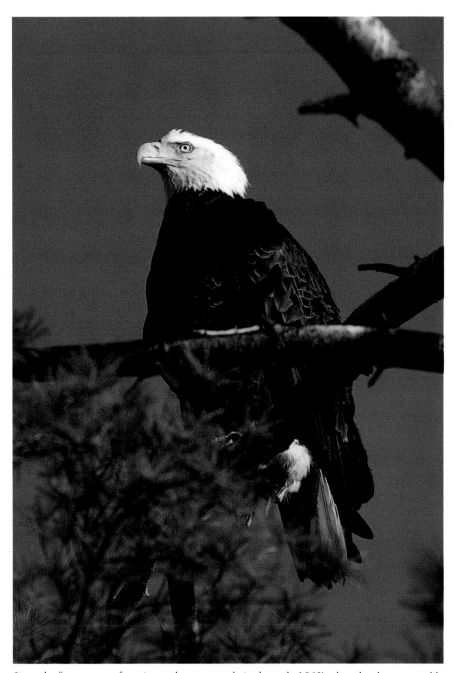

Since the first counts of nesting eagles were made in the early 1960's, there has been a steadily growing, healthier population. Most importantly, the ban on certain pesticides like DDT enabled this fish-eating scavenger to re-establish itself.

Photo by Gregory K. Scott

Wisconsin's forested area continues to increase in this century. The vanishing forest is a false impression if we include cultivated woodlots and industrial tree plantations. The forest has vanished though, if we wish to find old growth stands that developed over several hundred years, free of humans.

Photo by David L. Sladky

Prairie River, Marathon County. The golden aspen argues that even bare rock ledges and cliffs will be covered eventually with the growing plants. Aspen trees have a strong ability to colonize new areas by seed or by suckers from established individuals. Many aspen groups have highly connected roots and may have been derived from a single successful seedling. *Photo by David L. Sladky*

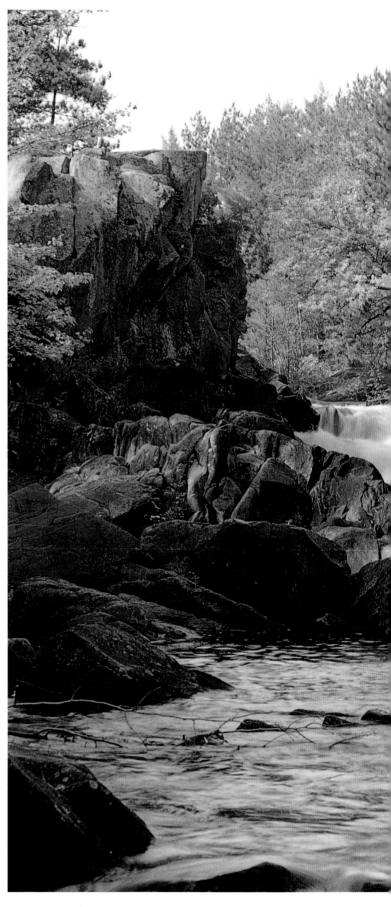

Dave's Falls, Marinette County. Waterfalls and northern mesic forest. The northern mesic forest – sugar maples, white pines, hemlocks, red oaks, and a handful of other tree species – dominated more than one-third of Wisconsin's original vegetation covering. Beech trees insinuated themselves into the mixture where Lake Michigan provided fog for extra moisture and heat from the lake water for a slightly longer growing season. *Photo by Mark S. Werner*

(Overleaf)

Raven Lake, Oneida County. White birch is closely related to quaking aspen. Both species quickly invade disturbed forests. But a lakeshore area makes a better home for the white-barked birch than for the aspen. Extra sunlight from the lake's opening in the forest and the small increment of heat from the lake's water in the fall may be useful to the growth of the birch.

Photo by Carol Christensen

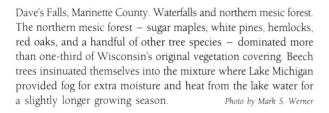

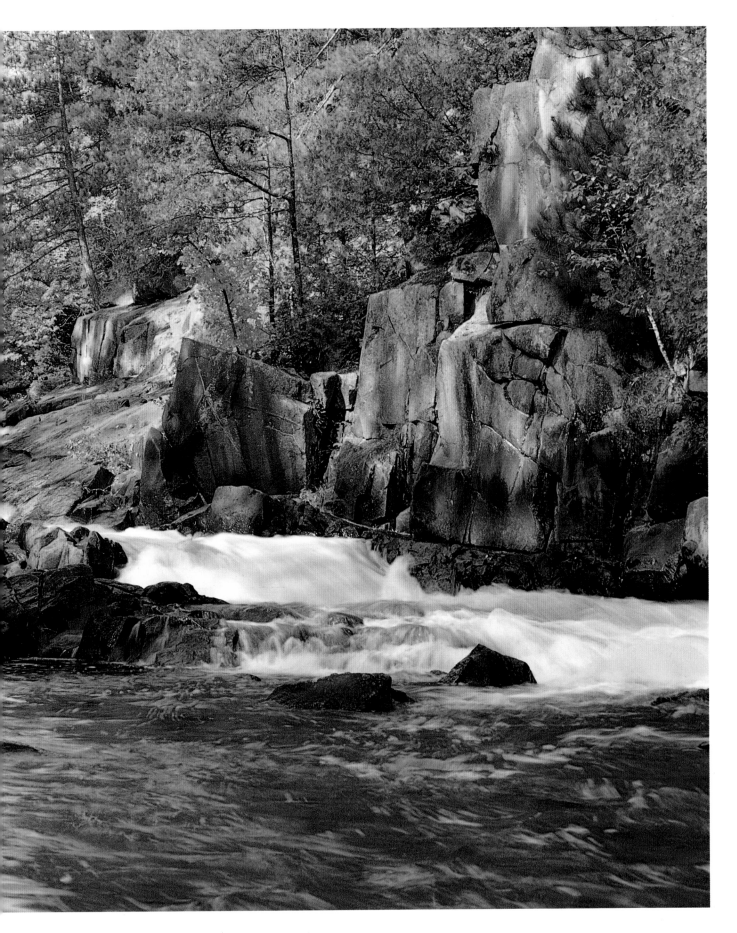

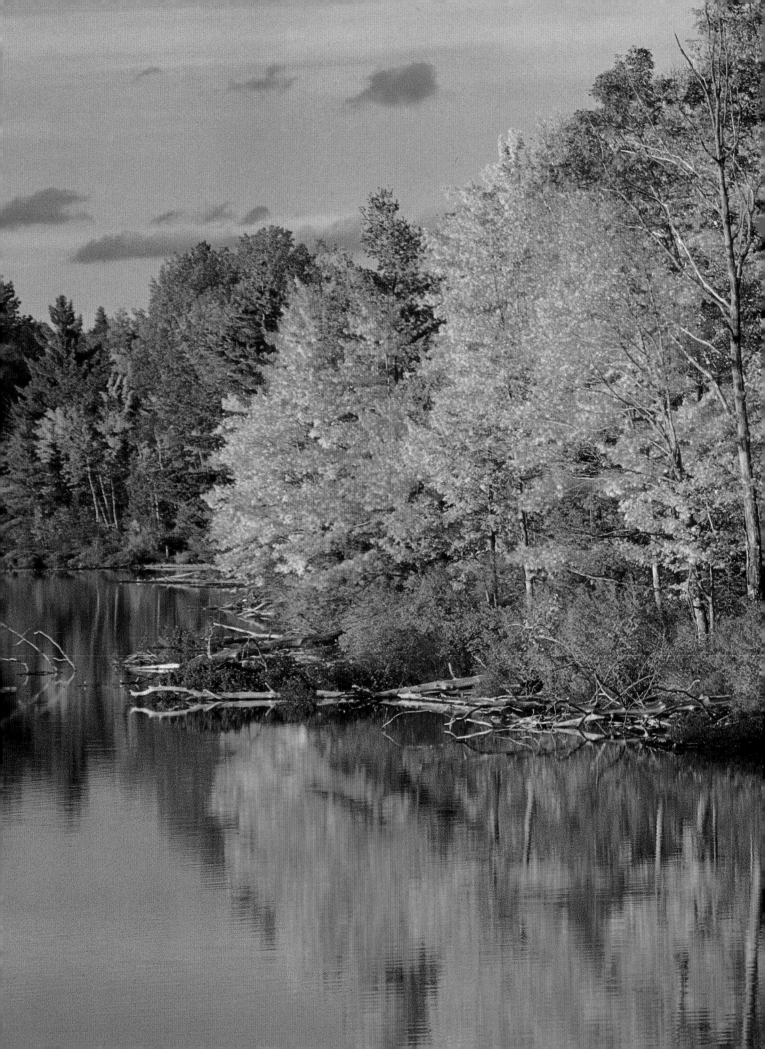

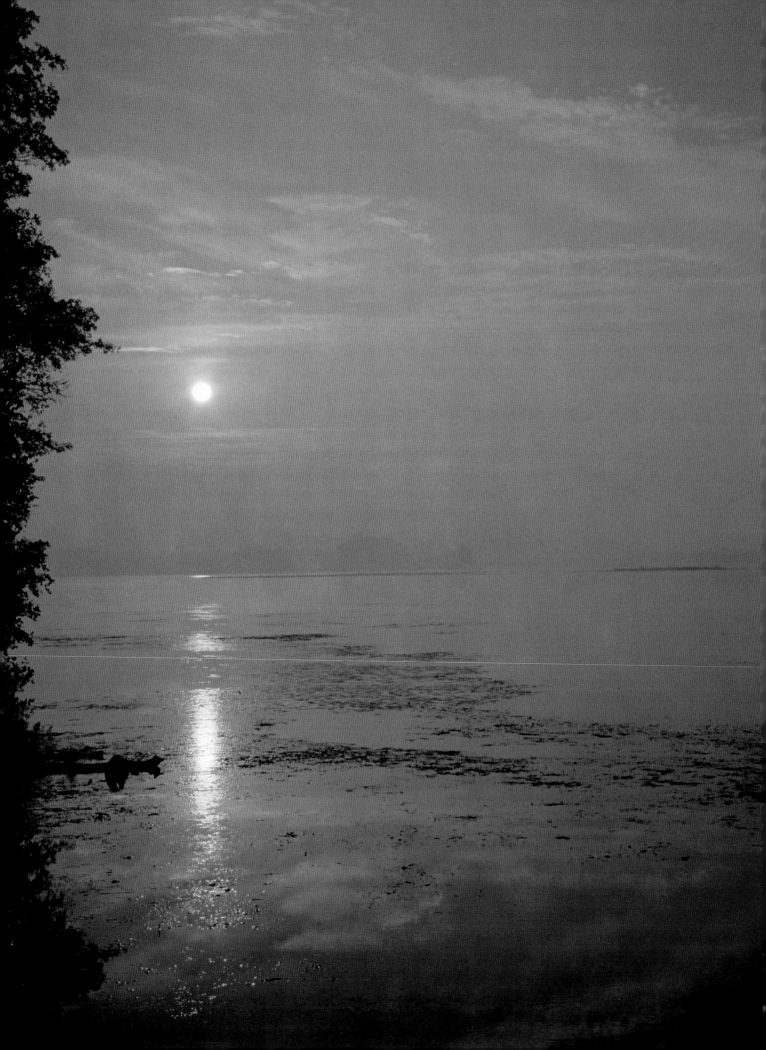

Sand beaches inhabited by native species are among the most difficult to find of Wisconsin habitats. Shoreline birds have been decimated. At this time, it is uncertain whether the piping plover is still able to breed in Wisconsin. Thousands of these beach-combing, sand-dwelling species used to occur in the open water season where recreational cabins, vehicles, and roaming pets now hold sway at the edges of many Wisconsin lakes. *Photo by Peggy Morsch*

Peshtigo Flowage. Are the beautiful sunsets over Wisconsin's lakes, rivers and flowages matched by the quality of sunrises? Although beauty depends on an individual's perspective, we do know that the reddish hue is more common in sunsets than sunrises. Although the sun's rays travel an equal distance through the earth's atmosphere in morning and evening, dust and smoke are more abundant at day's end, which produces more red. At either time, our eyes are pleased with the results. *Photo by Barb Schoenherr*

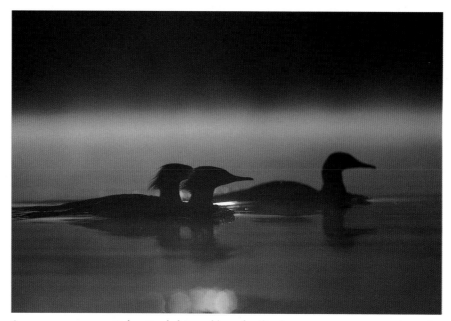

Common mergansers. Fish eating habits and large families keep mergansers constantly on the move for the minnows and small fish that keep them fueled. The merganser families on occasion surround a fish school, drive it into a restricted basin, and then concentrate all family members on feeding from the same kind of fish.

Photo by Dr. Scott Nielsen

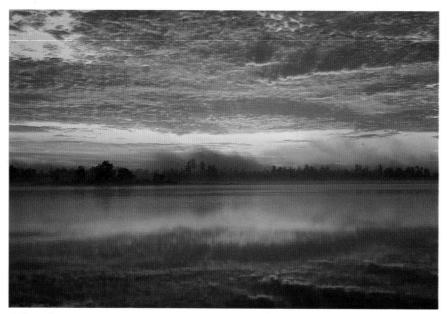

Willow Flowage, Oneida County. For many ospreys, fish-eating raptors, flowages like the Willow Flowage are more than adequate feeding and nesting habitat. Fluctuating water levels may even be to their temporary advantage as they secure fish to carry to their nestlings. They carry fish head first in their talons, seemingly in order to streamline their flight. Watch for bald eagles on the Willow Flowage, too.

Photo by David L. Sladky

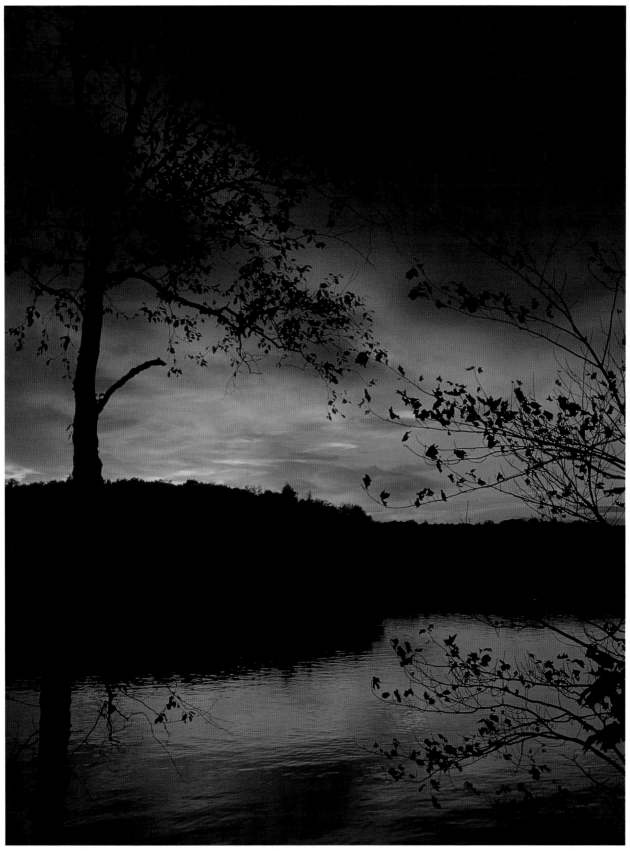

White Sand Lake, Vilas County. Many lakes receive groundwater. This is water which moves in the darkness out of our sight but not beyond our influence. While clean, clear water depends on the distance the water flows, the porosity of soil and rock, and the quality and quantity of vegetation on the land, replenishing waters also depend on humans for care of septic fields. With a little effort, there will always be sunsets to enjoy across cool, clear lakes.

Photo by Carol Christensen

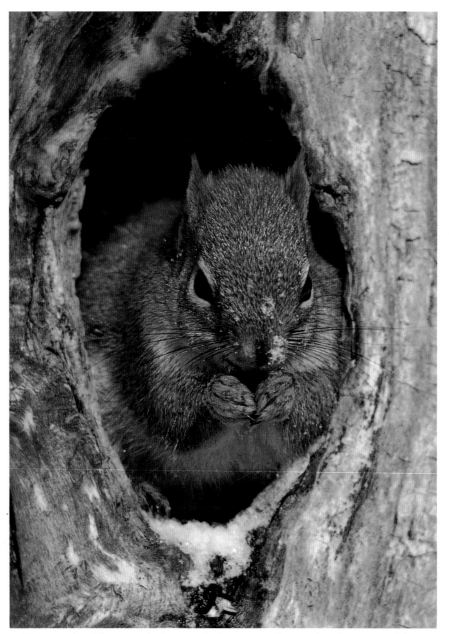

Unlike its grey and fox squirrel relatives, which are somewhat social, and once in awhile even gregarious, the red squirrel finds group life annoying and evolutionarily unnecessary. It feeds on pine and other conifer seeds within the tree's female cones and is able to defend itself in single territories. The red squirrel is more of a northern Wisconsin inhabitant, whereas southern Wisconsin residents are more likely to have grey squirrel neighbors. *Photo by John Gerlach*

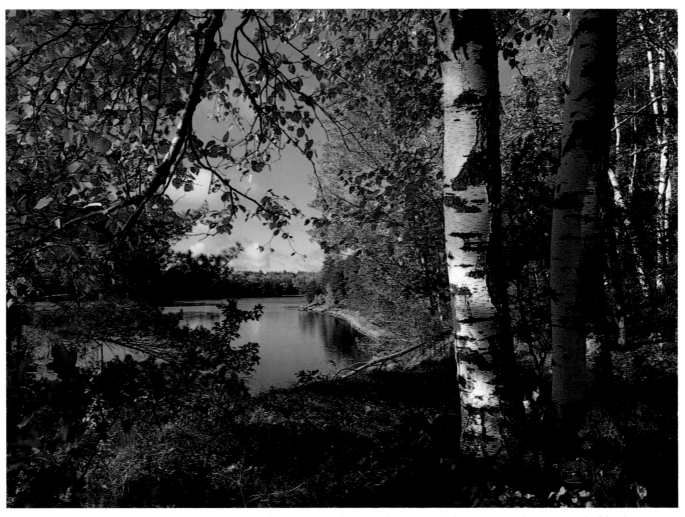

Wisconsin River, Oneida County. The bright yellow, red, and orange of autumn leaves reveal plant pigments that were masked by the stronger green of leaf chlorophyll. Light is essential to processing nutrients, and energy must be trapped in the leaf. Because light comes into the forest in different wavelengths, different pigments exist to trap light at some of the different wavelengths. What results are the brilliant autumn forests that cover much of the state.

Photo by Robert W. Baldwin

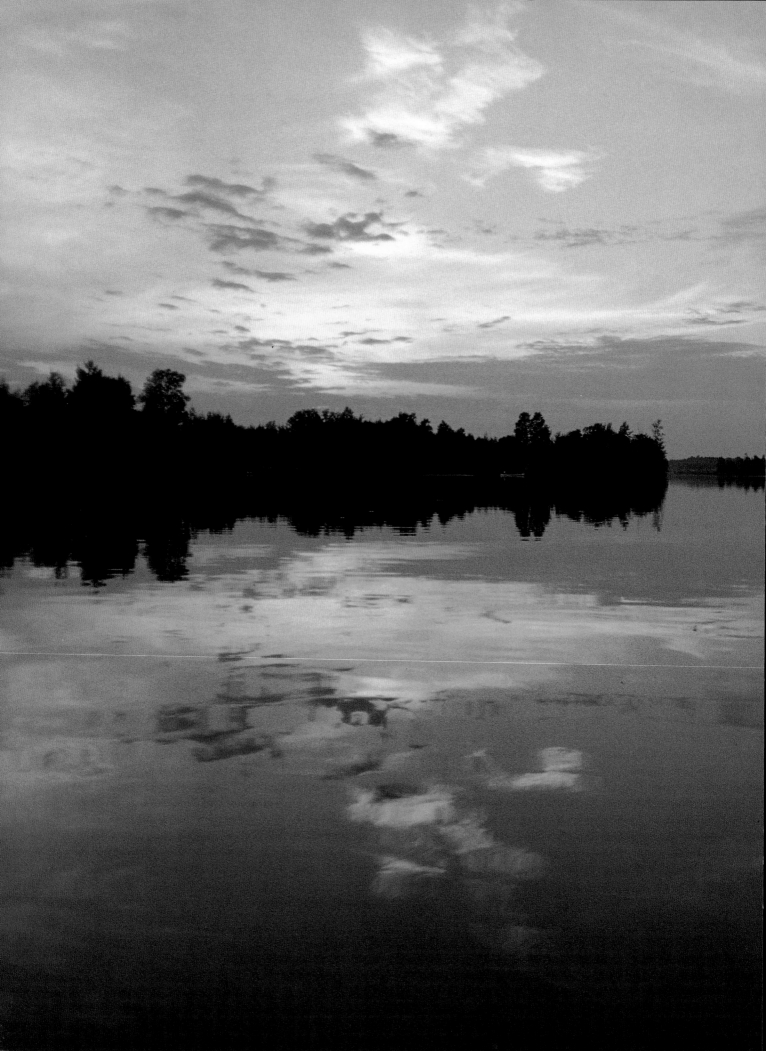

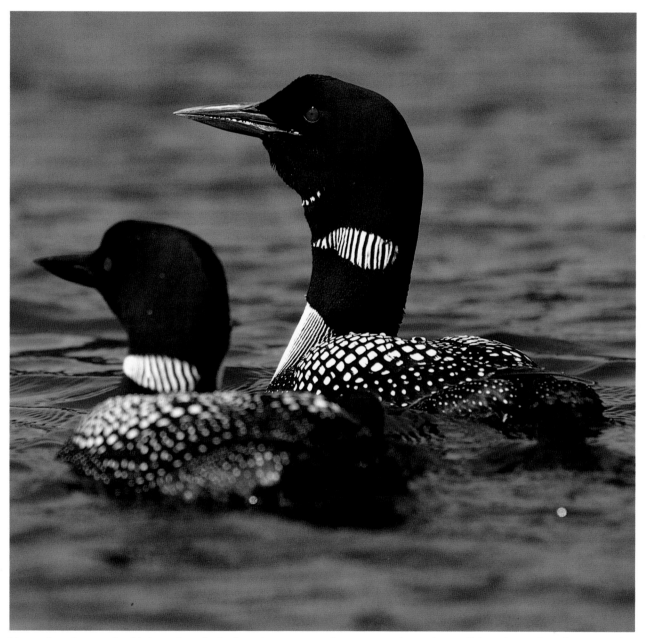

Mercer, Iron County. Good lighting from the back, and proximity to these common loons shows off the red eye. The red pigments that are so prominent help the loon to accumulate sufficient light to see fish at depths. *Photo by Robert W. Baldwin*

Soo Lake, Price County. Dusk is an eventful time in wild Wisconsin. Predators of the day have their last chance to get a full belly before sleeping, while barred owls and other predators of the night may have just a few moments to pick one frog off the water's surface before the frogs are away and out of reach. *Photo by Robert Queen, Wisconsin DNR*

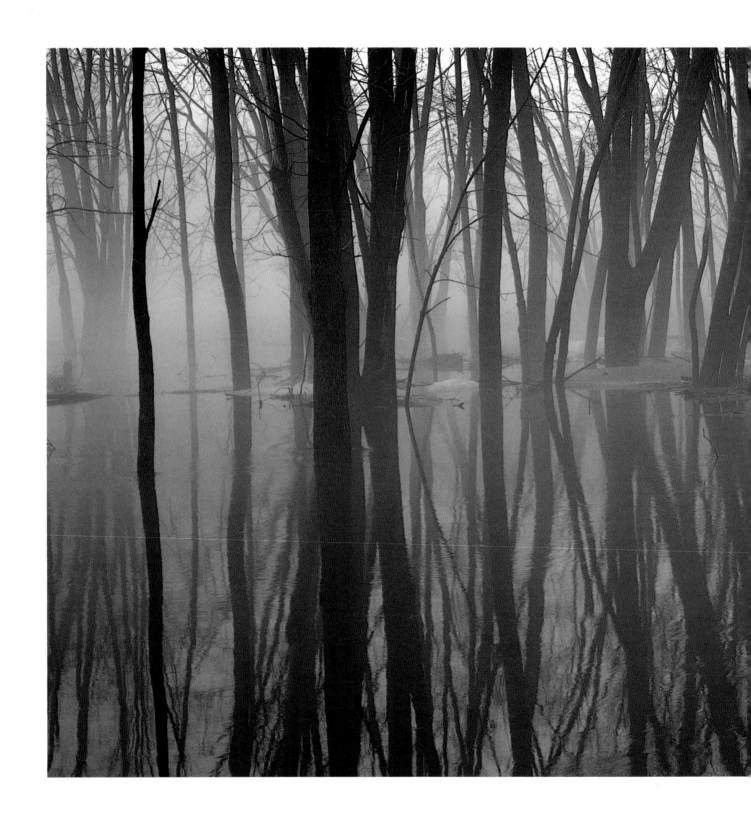

Rainbow Flowage, Oneida County. Rain on the way! What might signal the end of fishing from a small boat, signals something more essential for the waterways of Wisconsin. Although a sizable fraction of Wisconsin's precipitation is exported by rivers or by movement into ground water, what's left keeps wild Wisconsin green and lush. *Photo by Robert W. Baldwin*

Water and nutrients carried in flood waters are now most often doled out in "managed" rivers rather than dispensed expansively and in the natural abundance of a wild river. In the few forest habitats that still flood, trees grow bigger and farther apart. If a flood endures in the spring, fish such as northern pike may find the conditions right to spawn in flooded areas, reclaiming another part of Wisconsin for the wild. *Photo by David L. Sladky*

(Overleaf)

At the edge of any of many Wisconsin forests, you may find strawberries in bloom. Find a strawberry plant deep within a shaded forest patch and you are likely to see only the leaves and runners. Sunlight and warmth are necessary to produce flowers, and perhaps later the fruit. Yet the strawberry plant can persist for years without such an advantage. *Photo by Barbara Gerlach*

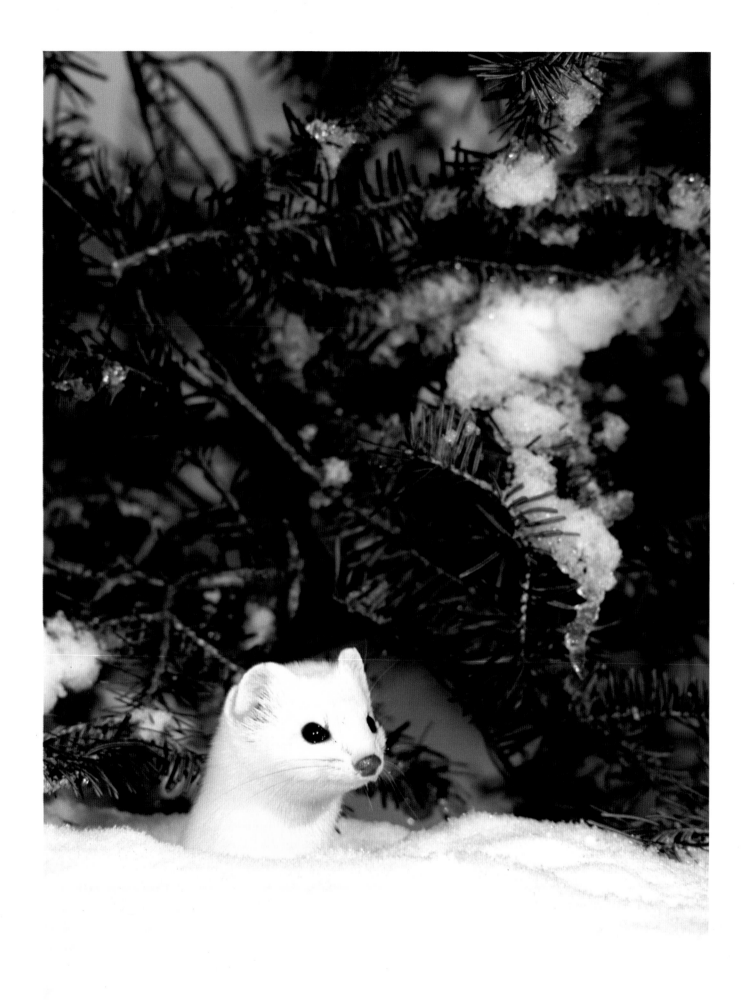

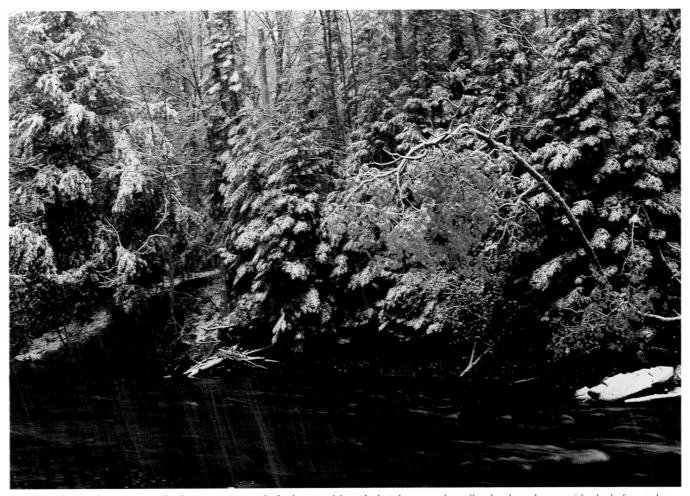

Prairie River, Marathon County. The forest trees not only feed stream life with their leaves and needles, but branches provide shade for a calmer, cooler microclimate around the stream. Some species are particular about the water temperature. High temperatures can be disastrous for baby brook trout.

Photo by David L. Sladky

Like hawks and owls, the weasel species have larger females than males. It may be that this is due to access to prey animals of different sizes, larger for females and smaller for males. Another possibility is that having a larger body for the purposes of egg-laying or harboring developing embryos holds a biological advantage for the females of each species.

Photo by Gregory K. Scott

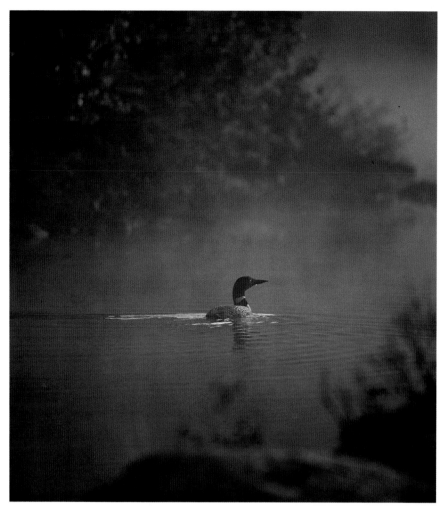

Arbor Vitae, Vilas County. Common loon. Territories for loons are the protected areas in larger northern lakes. Male and female loons reinforce their bonds by ritual displays, mate and lay eggs in shoreline nests out of the water. Later, they leave with fledged young to find ice-free water on southern wintering sites. Largest loon aggregations, quite unlike the family groups which defend territories, occur during the fall migration and take place on large lakes far from shore, such as on Lake Michigan. *Photo by Robert W. Baldwin*

The white pine is a standout in most Wisconsin forests. It is the only tree species that regularly grows beyond the height of the other species in the forest canopy. What might have been a uniform skyline in a sugar maple and basswood stand has a lot more variation with the white pines. *Photo by David L. Sladky*

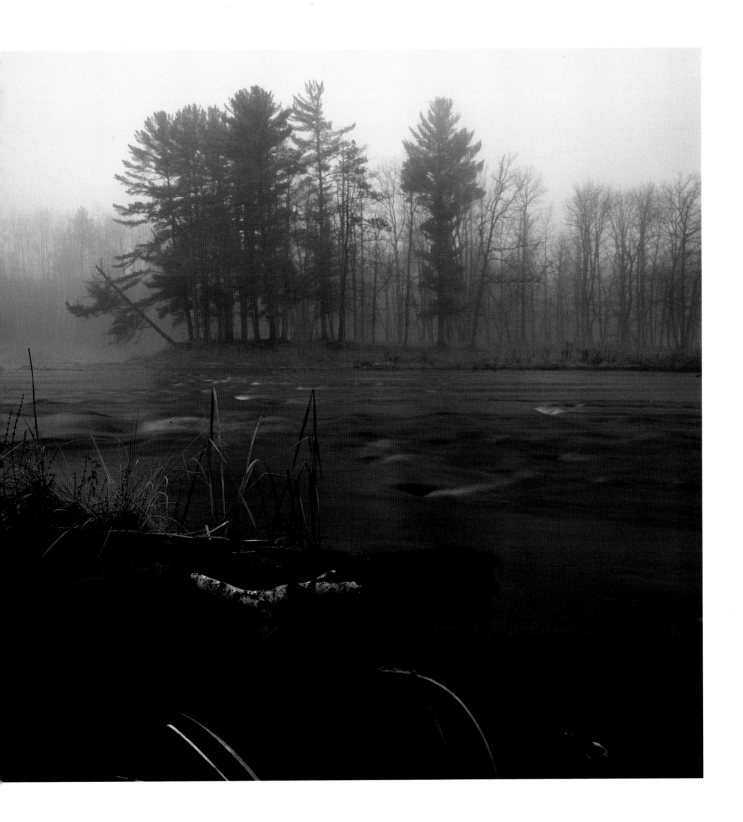

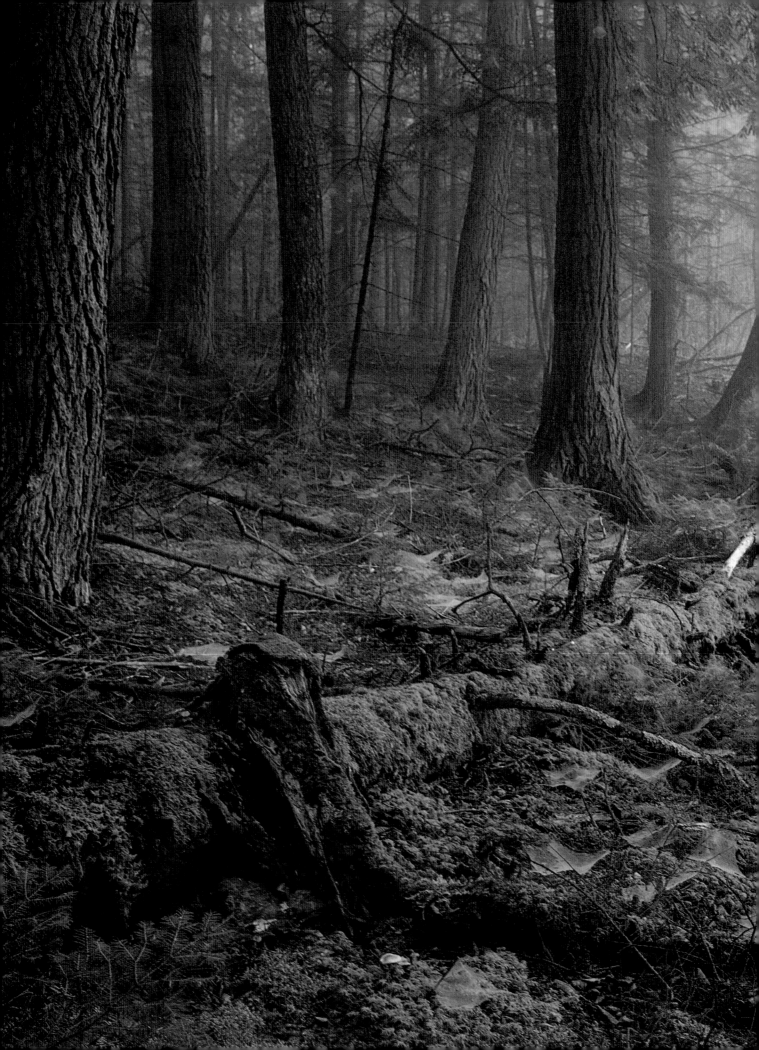

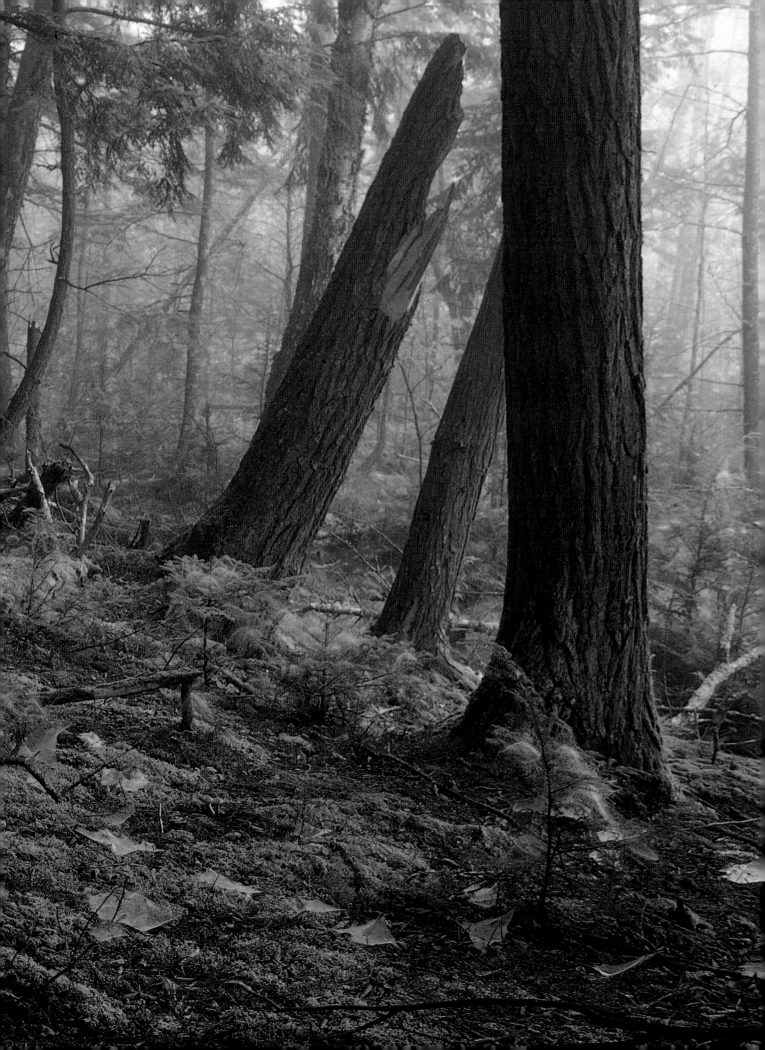

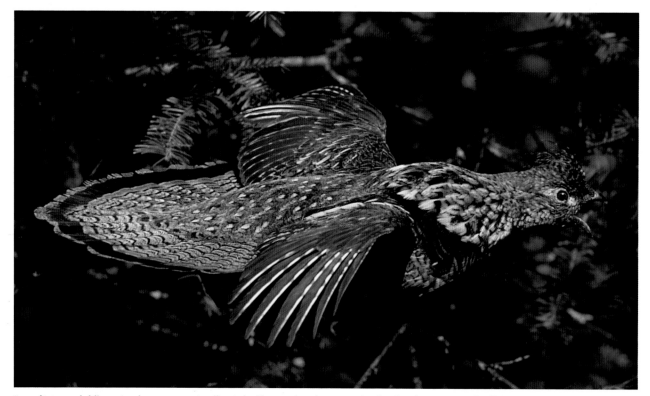

Sounding much like a simple tractor engine that is badly tuned and starting slowly, the "drumming" of ruffed grouse is the announcement of spring to many people. Drumming counts affirm that this species population varies. The apparent rhythm in Wisconsin for ruffed grouse shows relatively high numbers during years close to the end of a decade, and lows early in the next decade.

Photo by Dr. Scott Nielsen

(Overleaf)

The spiders who spin webs may have long spells without catching prey in the web. The "sit and wait" approach to dining works for some spiders because body metabolism slows to conserve the food from the previous meal. *Photo by David L. Sladky*

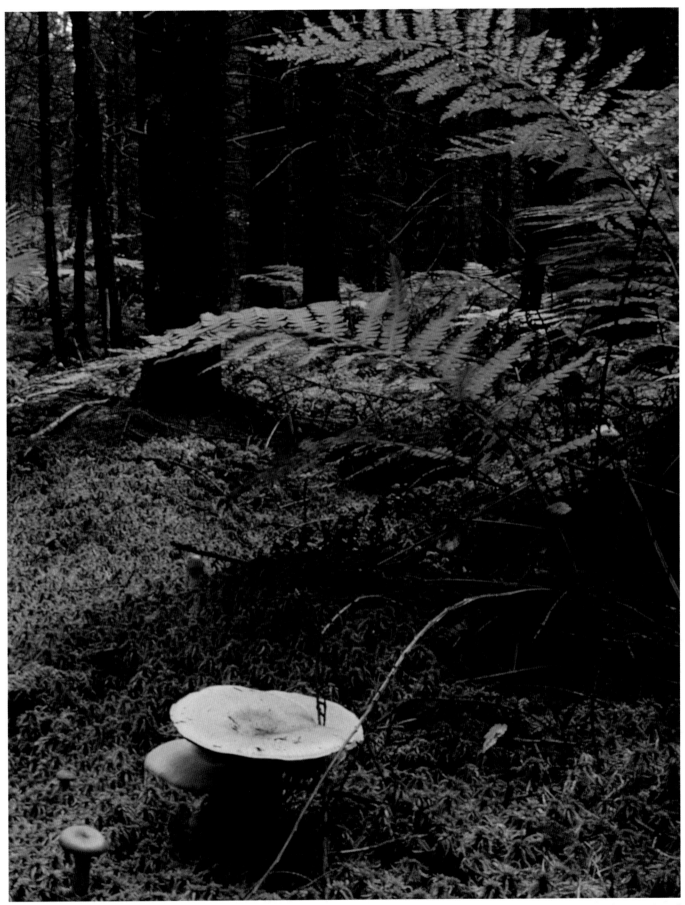

Spruce-hemlock bog, Taylor County. Shade within a forest often intensifies as the forest matures. Species such as hemlock have dense arrays of needles which very effectively capture sunlight to the tree's benefit. The diminished light below the dominant hemlocks is suitable for only a few understory plants compared to the riot of green varieties living below more open grown oaks. Mosses and mushrooms give a fairyland aspect to an older hemlock forest.

Photo by Gregory K. Scott

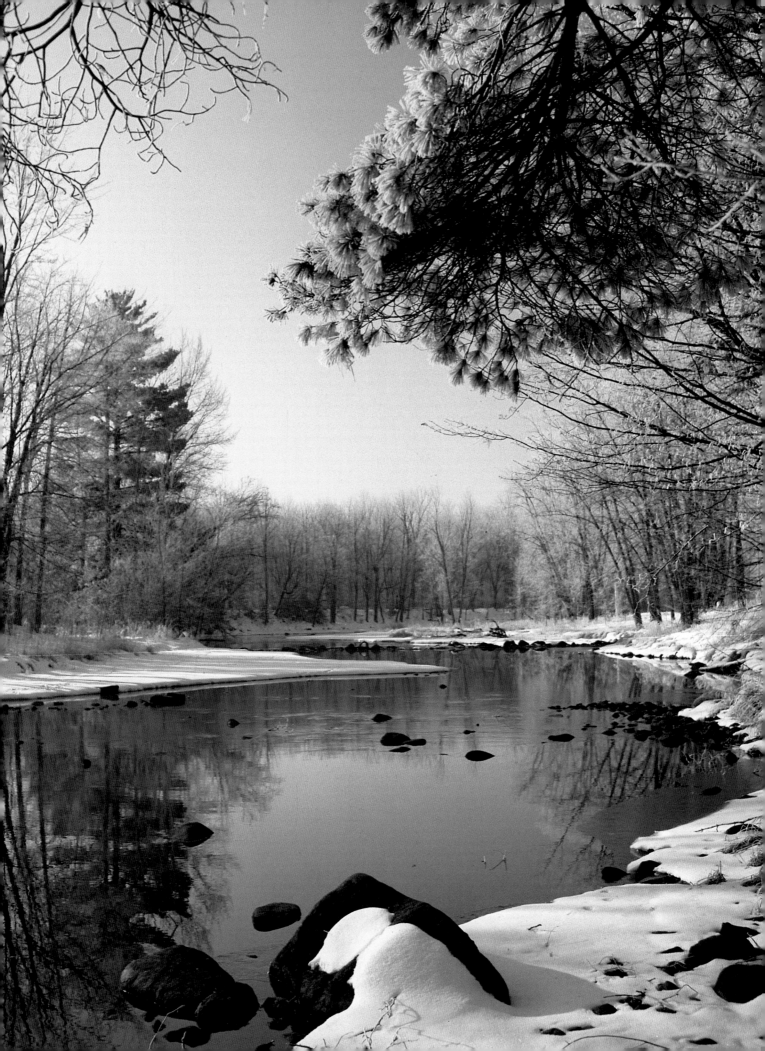

SOUTH FROM LAKE SUPERIOR

Our present intention is to reach the river where our journey began. The cold Lake Superior water lapping at the shore where we have beached the canoe seems a great distance from Prairie du Chien and our Mississippi River origin.

We can reflect that only time separates us from the voyageurs who may have stopped at this same spot on the way to the same destination. We can draw comfort and encouragement from the fact that they launched their birch bark canoes in Montreal. If they could finish their journey after that long paddle west, we can surely find the will to press on.

Their craft would have been unloaded here and then loaded again on the first navigable stretch of the Brule. The river seems to flow into our faces out of the south, out of the red clay and stone hillsides of Lake Superior's margin. Once on the Brule, the voyageur crews would have paddled whenever and wherever possible. But the Brule flows steeply and hard now and then. The voyageurs would have had to line their canoes or push their canoes while wading in the cold Brule water or portage their canoes and freight around the most difficult stretches. Perhaps the time spent in that manner would have been greater than the time spent paddling. In spite of the challenge, it is comforting to know that our journey will be similar; that the Brule remains essentially the same: a wild, free-flowing river.

As we prepare to depart we should consider where we are. Rifting, the separation within a continental plate, is what created the Lake Superior basin over a billion years ago. The process pushed layers of volcanic rock aside and made a low place in the earth's upper crust. That low area persists. In fact, thousands of years of water and ice in the basin have lowered it further by erosion.

What we face then on the Brule is both oncoming water and the fact that we are in a low spot. Since we cannot expect to be uplifted by geologic action before our food runs out, we had best check our gear and move out up the Brule toward the St. Croix River.

The Brule River valley that we enter was cut by the discharging waters of Glacial Lake Superior. In the opposite direction of the present flow of the Brule, Lake Superior waters carried vast amounts of clay far downstream – most of it ending in the Gulf of Mexico in a matter of days. Silt did not carry so far downstream, and sand carried but a small distance. The sand settled out quickly and covered the glacially scraped area around Bayfield and Polk counties. The pitted outwash plain that resulted is the upper part of the Brule River watershed and virtually all of the St. Croix River's watershed in Wisconsin.

Yellow River, Taylor County. An ice-free river in the wintertime is a feeding and resting place for bird and mammal predators of the river's fish. Mergansers and common goldeneyes frequently can be seen on the river's surface, while otters leave the "skid marks" of their tobogganing trails from the riverbank into the water. *Photo by Gregory K. Scott*

The depth and breadth of these sand deposits will not be apparent as we trek carefully up the Brule River. Alders and willows along the bank and white cedars in a second tier will be all we see. The background hills of the Brule's valley will be visible now and then, but not emphasized. We have the curse of the corridor traveler; seeing what is close up and little else. We subconsciously generalize the broader landscape from those impressions. In fact, a different perspective would be a good thing to establish. If we could fly up and out of the Brule valley and look all around we would have a better view of the landscape's character.

Despite our yearning to believe it so, broad expanses of large white pines and red pines were not common in northern Wisconsin. Forests were of both deciduous and conifer species. Variety, quite unlike the numbingly monotonic red pine rows that now dominate the Brule River area, was the historic case.

Back at the river it's cool, which is welcome after our walk in the red pines. In fact, if the wind is light it's possible to detect cold air drainage patches along the river. Small ravines are sufficient to concentrate cooler, denser air. Most noticeable in the spring and fall, "frost pockets" influence the trees and other forest plants. White cedar thrives in the depressions while the cold air is detrimental to its competitors.

Within a cool white cedar swamp, orchids and blueberries also thrive. The life cycles of these plants have much in common. Both these families require insects, not wind, to pollinate their flowers. Plus, they require "infection" by fungi to germinate seeds and grow. The pace of life is slow in a cool area, and it may be the greater portion of a human generation before a ladyslipper orchid seed makes its own flower and its new seeds. Typically more than half of the cedar swamp flowers bloom and fade before mid June.

White pines, and even red pines, grow on little islands of higher land in white cedar swamps. Black ash, tamarack and black spruce also find niches to their liking. Under it all is soft, spongy, water retaining sphagnum moss.

Upriver the terrain flattens and the river widens. White water gives way to beaver meadows in which we may find wild rice.

The role of beavers in Wisconsin is profound. Beaver, bison, blue jays, fires and floods historically have been the major agents of change on the Wisconsin landscape. Beavers built dams, killed shoreline trees by flooding the roots, cut and hauled trees away, and contributed to the buildup of organic matter. The pools created different habitats on otherwise straight, narrow streams. But by the time pioneers settled, the beaver trade had practically wiped the beaver out, and with it the good work it contributed.

During the travels of the voyageurs, the echoes of wolf howls certainly filled the Brule valley. Along with deer and even woodland caribou, the abundant beaver population of the valley provided a ready source of food.

The howl of the wolf can still be heard in Brule country. Not everywhere and not often, though. But, to the delight of many, wolves have returned to Wisconsin. Wolves have always prowled through our subconscious. For many the howl of a wolf is a fearful, unnerving sound. Some still believe wolves to be evil incarnate – soulless demons looking for small children to devour. Most now, however, accept the wolf as an integral component of the northern ecosystem.

There are plenty of deer in this state to feed the few wolves we have as well as the 600,000 deer hunters.

The return of the wolf happened very quietly. After decades of bounty hunting (a bounty of $20 per wolf was still on the books in 1957), the wolf in 1960 was declared extirpated here in Wisconsin. As taxpayers we had spent millions of dollars to destroy our wolves. Ironically, studies can conclusively demonstrate that wolves have minimal negative impact on deer and other wildlife populations. Wolves have been the victim of a bum rap.

In 1973 wolves were finally given full protection under the Federal Endangered Species Act. This protected the sizable (over 1,000) population in northern Minnesota. One at a time or in pairs, wolves drifted back to Wisconsin. Sometime in the mid 70's, people began to see and hear wolves again. In 1975 the Wisconsin DNR declared the wolf endangered here, and in 1979 a wolf research program was launched. The wolves have done most of the work. Given protection, their numbers have increased. Numbering just a few dozen at present, they're back in Brule country and in Vilas and Price counties. They're on the move again. Watch and listen.

At the top, nearing the Mississippi watershed, the Brule brings us to sedge meadows and even the hope of a canoe access onto the upper St. Croix. As travelers from voyageurs to tourists have always done, we seek the short, easy path.

Now we descend. The St. Croix begins its journey to the Mississippi modestly. The sands on the pitted outwash plain keep a high level of ground water which feeds the river, not the other way around. Except after successive years of drought, the upper St. Croix has enough water to move travelers.

We head to the southwest, and the direction is fitting for what we see. Pine barrens of jack, red and white pines are interspersed with prairie grasses. Sandy areas, perhaps blowouts, are encircled by vegetation which encroaches more each year. And there may be sandy soils stripped of organic matter at the surface because of severe fires.

Fires can be a detriment to wild things or a blessing. Within the St. Croix watershed one plant exemplifies the relationship. Because of the waxy substances in the cone, a jackpine tree releases its seeds just after a fire has passed through its stand. With a crowned fire, all adult trees would die. Through the fire, their generation is replaced and the species endures.

Down the St. Croix, the Crex Meadows Wildlife Area shows further how fires enrich the wildlife and the wildflowers. An accidental fire was monitored after the fact. The careful manager observed the increase in desirable native grasses and flowering plants, and was able to produce more enriched habitat by setting other controlled fires.

Beyond Grantsburg the rest of our journey is a leisurely float downriver onto the Mississippi in Pierce County, and from there, back to our beginning. It will not be a simple matter to choose what there is of wild Wisconsin that can be explored from here.

We can explore remnants of Great Plains prairies or opt for the black ash forests in the St. Croix River lowlands in Governor Knowles State Forest. We can venture back into Wisconsin's northern forest via the Namekagon River or the Chippewa. The outcomes will be chosen by caprice, and will be known to those who hear the stories. If Wisconsin's campfires had ears, wouldn't we be pleased to include our travel stories in the landscape history of wild Wisconsin?

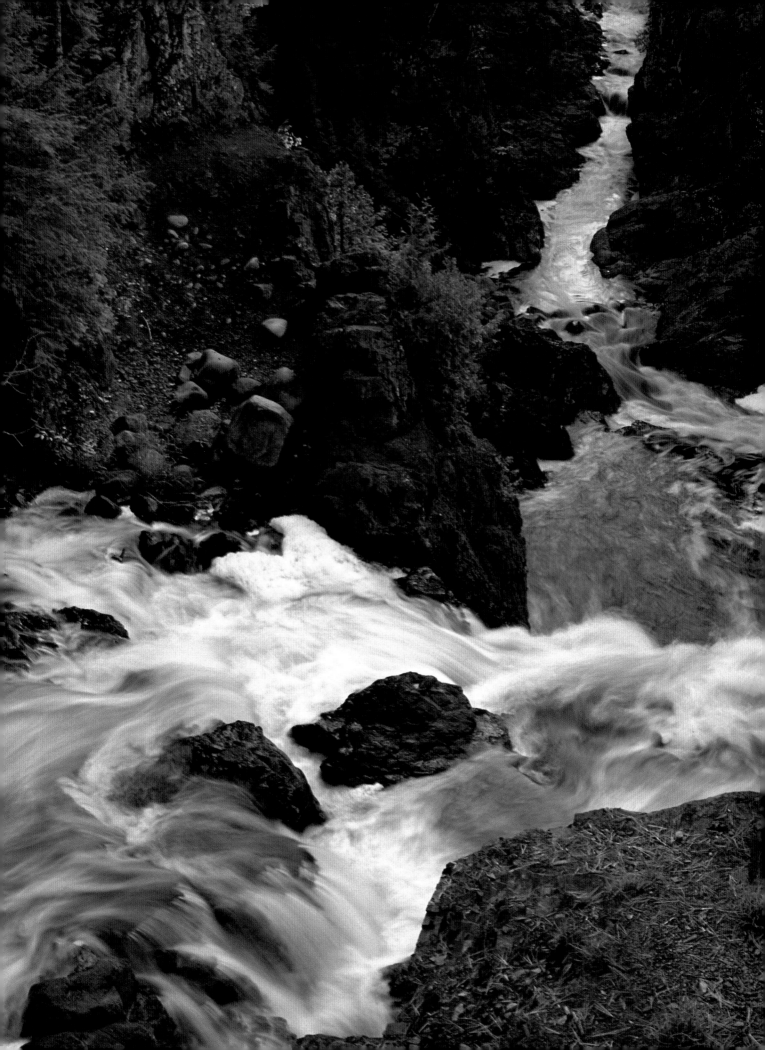

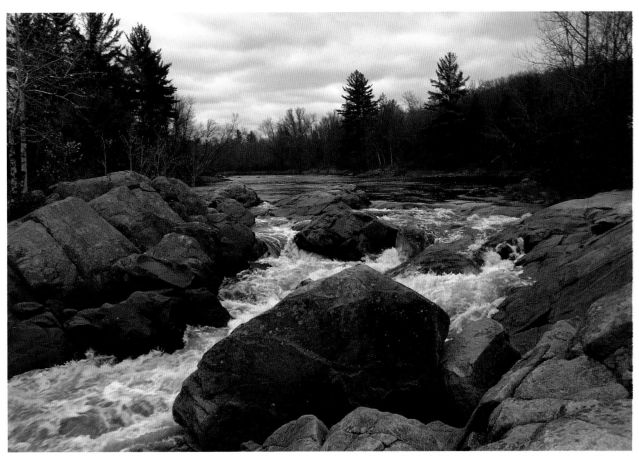

With a dark sky above and tan water below, countless logs from Wisconsin forests flowed down the rapids of the Flambeau River. A few rapids are built up with sharp-edged rocks that are danger to a canoe's thin skin. Sharp-edged rocks in a rapids are human work, not the roundedness that nature would have provided the modern river traveler. Dams were occasionally built to raise water levels and then burst to better carry logs and log drivers downhill to the sawmill. Sharp remnants of those dams remain. *Photo by Mark Wallner*

Copper Falls State Park, Ashland County. Brownstone Falls. An aptly-named rock, brownstone of far northern Wisconsin, is resistant enough to create good, plain building elements and similarly is able to tolerate hundreds, and maybe thousands, of years of falling waters. *Photo by Carol Christensen*

(Overleaf)

The wave spray and splash on sandstone evokes the living and active spirit world of the first Chippewas, or Anishanabe, of Wisconsin. For Anishanabe, termination of free movement in the State came with the final treaties signed here at Madeline Island. This is also the center of the Chippewa legend of migration and arrival. A rough translation of the Anishanabe word "Chequamegon" into English would be "water breaks place," certainly apt for the windy, wave-shaped Apostle Islands. *Photo by Bruce Fritz*

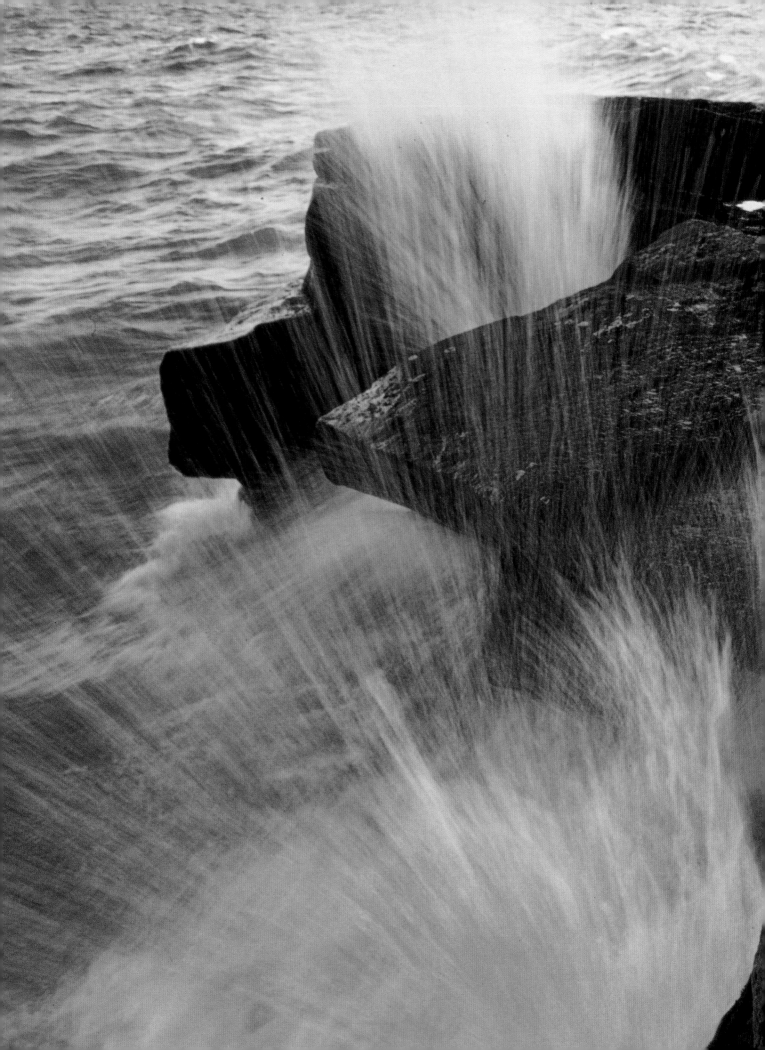

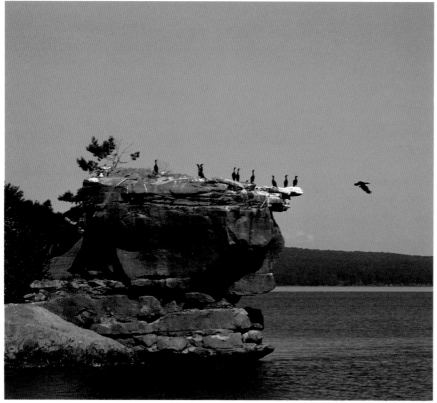

The double-crested cormorants on Lake Superior are predators with a broad distribution. Their numbers and "colonies" in Wisconsin are greater because of the reduction of chlorinated hydrocarbon pesticides and the introduction of man-made nest sites. Whether they are a serious competition for human fisherman is an open question. Their presence sparks animated tavern discussions across much of northern wild Wisconsin.

Photo by Mark Wallner

Willow Flowage, Oneida County. High humidity benefits most Wisconsin trees and other plants although it tends to soften distant views and reduces our visibility. Leaves capture moisture and let it drip to the ground where with the dew, it adds to the water available to plants.

Photo by David L. Sladky

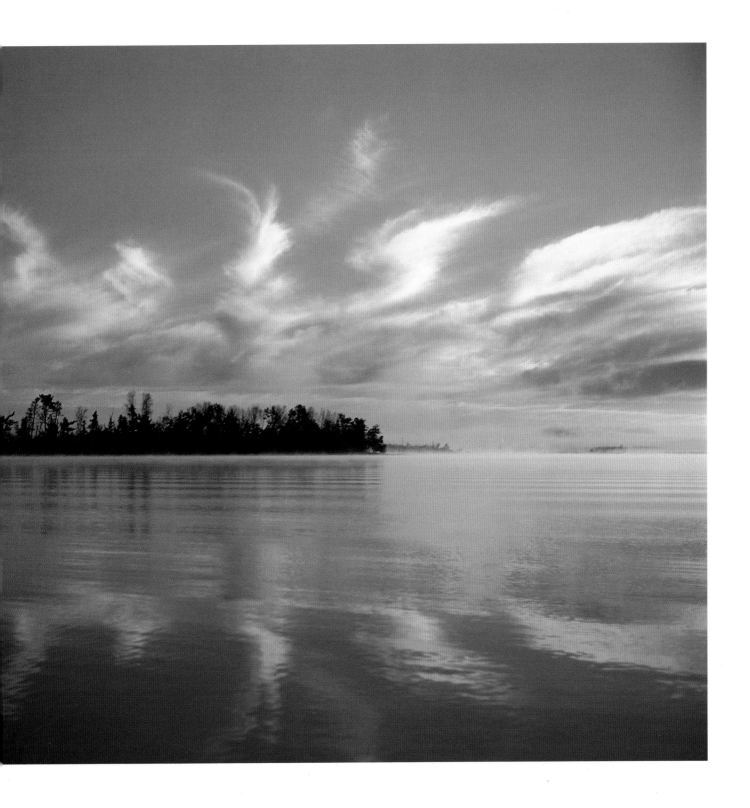

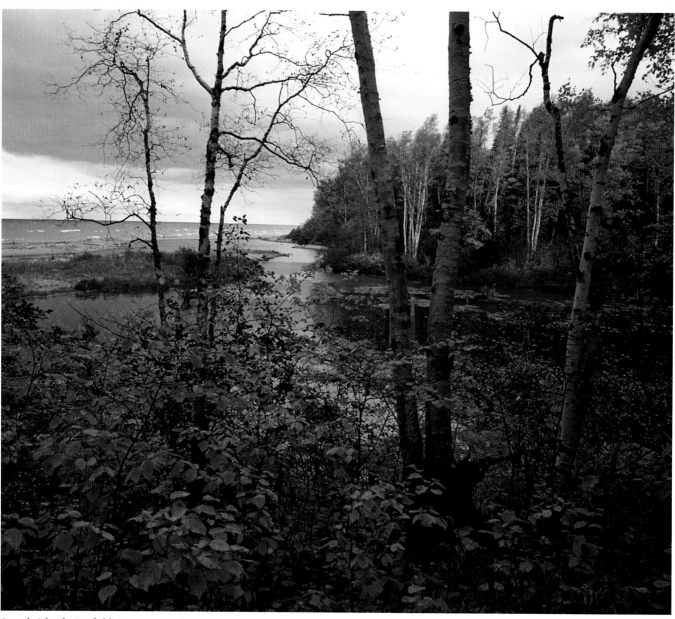

Apostle Islands, Bayfield County. Apostles. An arch at the top of a cave cut by Lake Superior into Madeline Island waves shows the strength within this "deep sea, shining water" if wind joins it in force. Neither rocks nor great ships are safe from waves here. Sand, however, may be more successful than rock with a strategy of "removal" during storms and subsequent replenishment by the current. *Photo by Bruce Fritz*

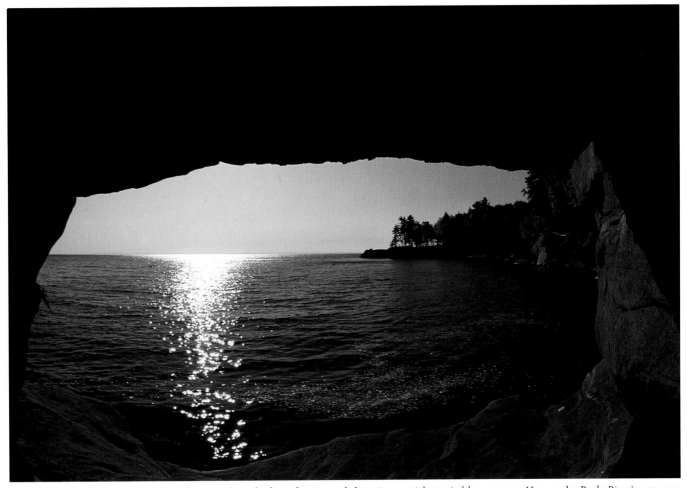

A sandbar may develop where rivers flow into large bodies of water and deposit materials carried by currents. Here at the Brule River's entrance into Lake Superior, we can imagine French voyageurs with their priest and soldier leaders landing here to begin travel up this young Wisconsin river.

Photo by Bruce Fritz

(Overleaf)

Many waters in the state are stocked with rainbow trout or fall migrating brown trout to the advantage of fisherman. Rainbow trout survive in many different coldwater habitats from streams to the Great Lakes.

Photo by Don Blegen

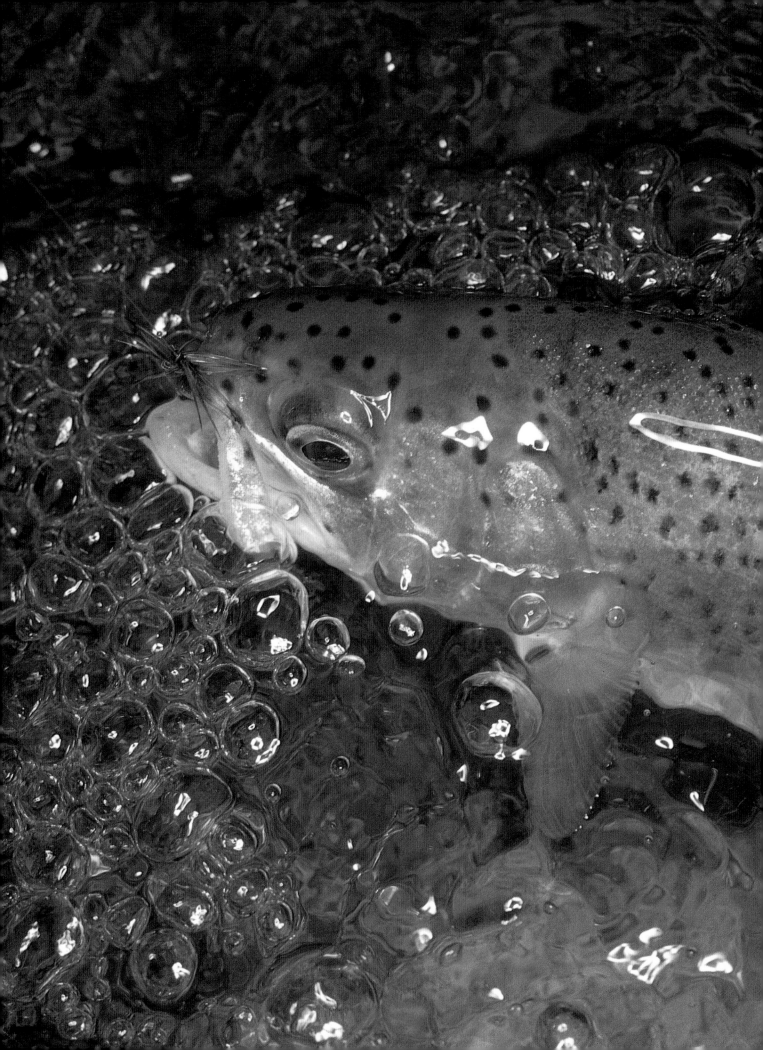

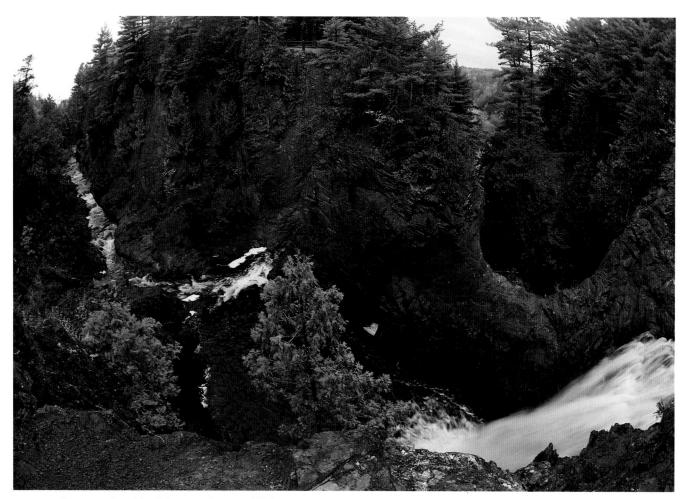

Copper Falls State Park, Ashland County. This waterfall shows that rivers paths change in time. The rounded ledges are an indication that flowing water shaped these rock formations. The miniature buttes or mesas that remain exist as islands of forest within the river, and as some of northern Wisconsin's most picturesque scenery.

Photo by Bruce Fritz

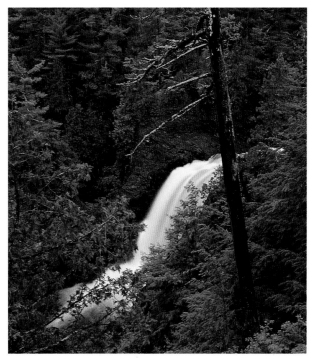

Bad River, Ashland County. The dead standing tree that frames this waterfall will be a house for birds long after its bark has hit the ground. Particularly in northern Wisconsin where cooler temperatures and shorter growing seasons have their influences, trees may remain standing for years after death. Stumps, too, are much more likely to stick around, perhaps even for a couple of decades after they would have turned to Southern Wisconsin dust and soil.

Photo by Gregory K. Scott

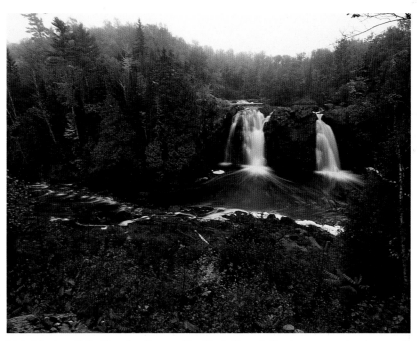

Little Manitou Falls, Douglas County. The Black River belies its name as it takes on air in the first of two major waterfalls among a red pine plantation. Further downstream, the river appears dark as organic matter from the white cedar swamps, sphagnum bogs and black ash wet forests that the river navigates contribute tannic acid to its waters, resisting breakdown of the organic matter in the cool water and absorbing light.

Photo by Dr. Scott Nielsen

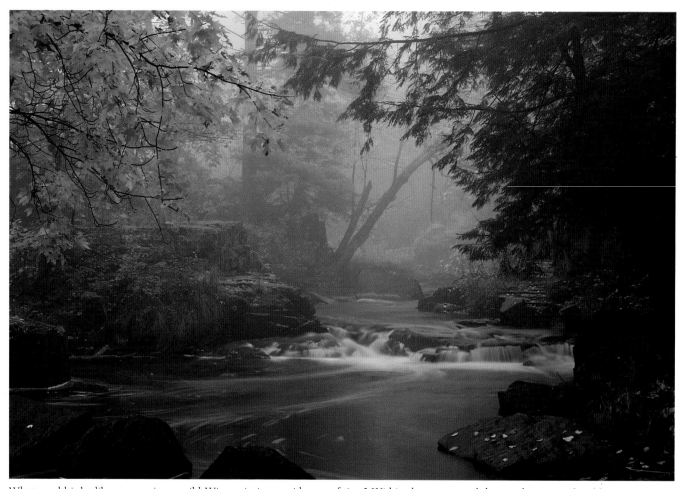

What would it be like to experience wild Wisconsin in an arid span of time? Within the past several thousand years, arid, cold times persisted for centuries. Streams undoubtedly dried up completely, and lakes certainly shrank. The upland vegetation, too, would have differed greatly. Prairie grasslands perhaps would have supplanted oak savannas, while oak savannas probably replaced oak forests in those dry centuries. At a place like Eau Claire Dells, it's easy to take water for granted.

Photo by David L. Sladky

Animals within a stream rely heavily on what falls in and then can be eaten. The yellow leaves on the stairstep Morgan Falls would be trash for the dump in a city; here they provide life itself for a chain of bacteria, detritus-feeding stream insects, dragonfly nymph carnivores and brook trout, the carnivore of carnivores.

Photo by Mark Wallner

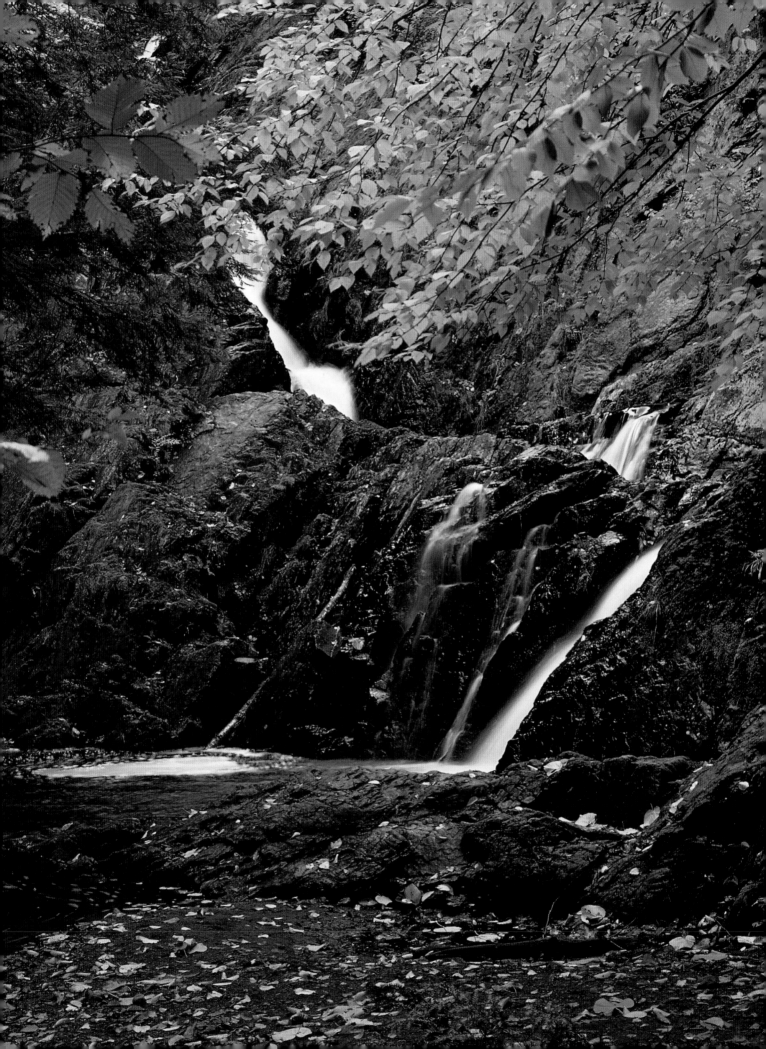

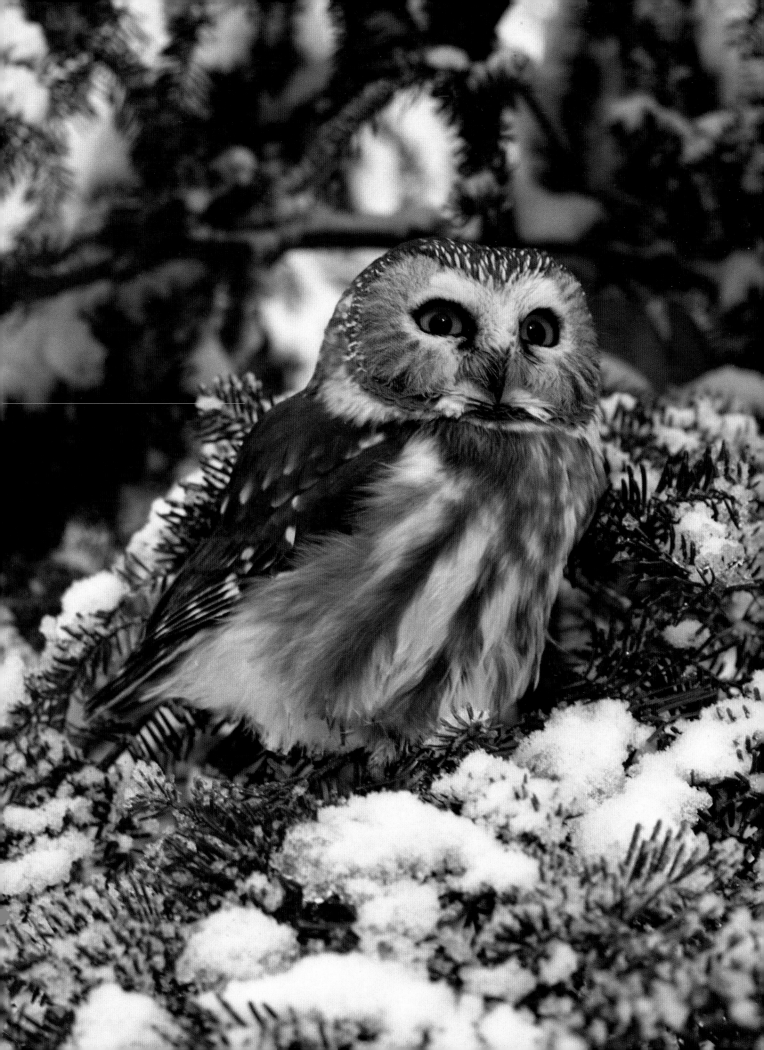

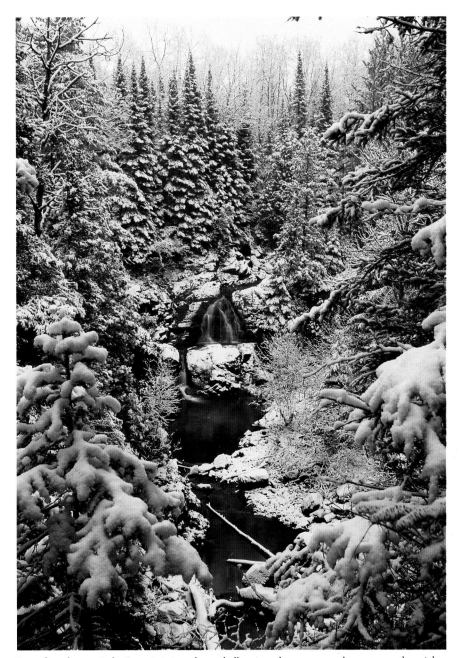

Even though most Lake Superior rivers have challenging, short, steep paths, not even the mighty sturgeon have the power necessary to migrate beyond this falls. Only the native stream lampreys might have a chance, their flexible eel bodies moving from one wet rock to the next in search of adequate spawning beds.

Photo by Dr. Scott Nielsen

The owl's characteristic wide-eyed appearance is emphasized by feathers that seemingly radiate from the eye. Owls have a capability for vision in low light that exceeds that of most other bird carnivores. But what about the feathers around the eyes? Their role seems to be in funneling sounds to the ears. A shrew or a cricket would not only have to be invisible, but silent, too, to avoid detection by this saw whet owl equipped with visual and auditory detectors.

Photo by Dr. Scott Nielsen

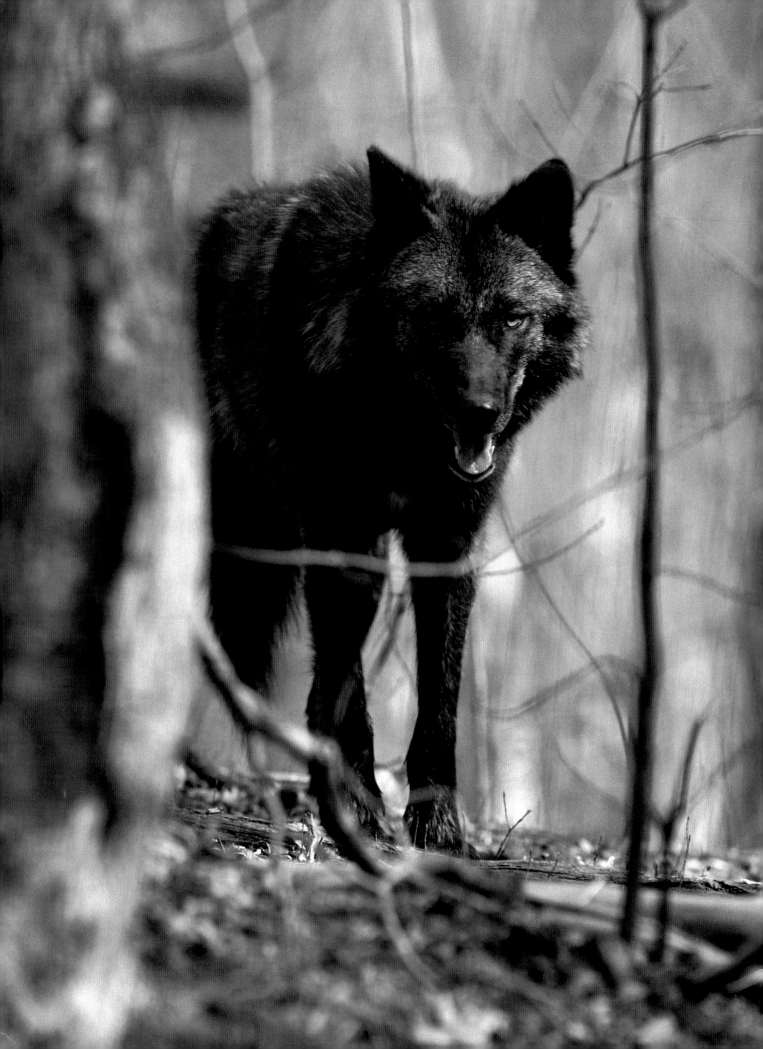

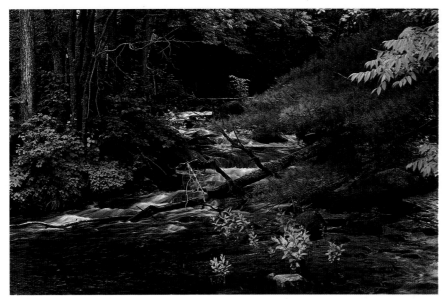

(Top)

That a stream moves downhill is obvious; gravity's force makes a pull that is irresistible. But how does a stream move from side to side? In a manner that resembles the wave pattern we would see on an oscilloscope, the stream dissipates energy into the banks and bottom, gradually wearing them away. If the stream's edges are of hard material, like granite, the energy is dissipated with difficulty and the resulting river curves are very gradual. *Photo by John Rasmussen*

(Bottom)

Stream water, as it bubbles over rocks and other stationary objects, picks up oxygen so vital to the existence of fish, frogs and other water dwellers. *Photo by John Rasmussen*

The decade of the 1980's will be known for the return of the timber wolf in Wisconsin. The return of these animals into previously wolf-rich habitat took place as individuals or an occasional pair dispersed out of Minnesota to the east. Timber wolves show a great variety of coat colors with black being fairly common. *Photo by Robert W. Baldwin*

(Top)

Jag Lake, Vilas County. Sound travels from source to ear with ease in the stillness of fog. Poor lighting makes our eyes incapable of perceiving depth in landscape features. It makes for an interesting time to paddle quietly along the lakeshore's edge as the trees begin to adjust to the changes winter will produce.

Photo by Carol Christensen

(Bottom)

Copper Falls, Ashland County. Waterfalls are impediments to fish as well as human passage along rivers. If the falls are as high as this one, migrating native fish such as lake sturgeon are blocked. The pools below waterfalls may have concentrations of fish even today at spawning time.

Photo by Bruce Fritz

Black River State Forest. Jackson County. The Black River, former path of discharge for Glacial Lake Wisconsin seems calm and pastoral. Surging waters of the melting glacier drained out to the Mississippi via the Black River for a few centuries before the big glacial lake and the pre-glacial Wisconsin River were reunited.

Photo by Mark Wallner

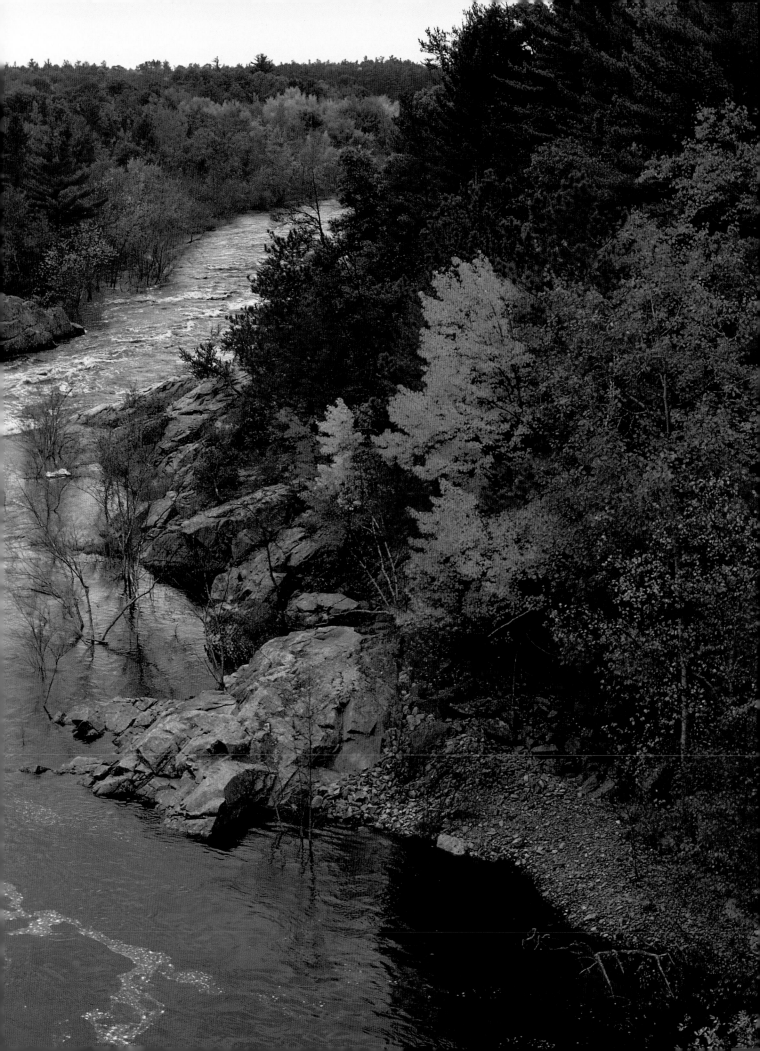

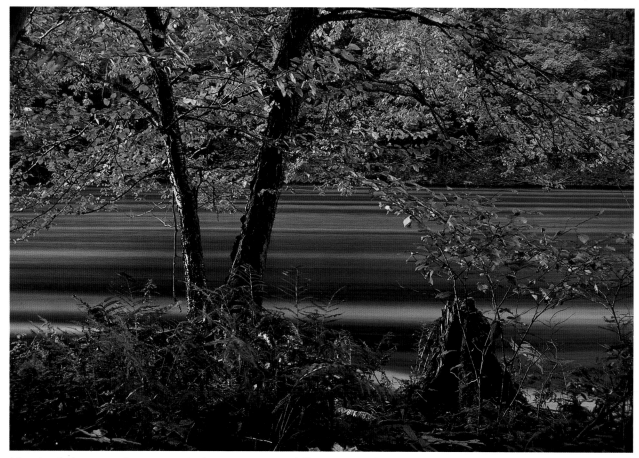

After the glacier retreated, trees came back to Wisconsin in different groups than their present assemblages. Among the first trees to resettle the former ice sheets were black spruces which could tolerate the bare ground but were supplanted by other faster-growing trees which arrived later.

Photo by David L. Sladky

(Overleaf)

Within a forest, the soil is enriched if logs and stumps decay in place on the ground. Fungi play an important role in this decomposition as well as helping live trees to bring in water and nutrients. Some of these fungi produce mushrooms which are not only functional, but beautiful as well. *Photo by David L. Sladky*

Little Manitou Falls, Douglas County. It is not only a river that has a break in continuity during its waterfall. The geologic situation produces the waterfall. Hard rock may top soft rock which has eroded away, leaving a flowing water cliff; or a fault stretching for miles may have caused the drop. As hard as the rock is in any place, it is never a match for flowing water. Waterfalls exist for just a short span of geologic time as eroding waters do their work.

Photo by Gregory K. Scott

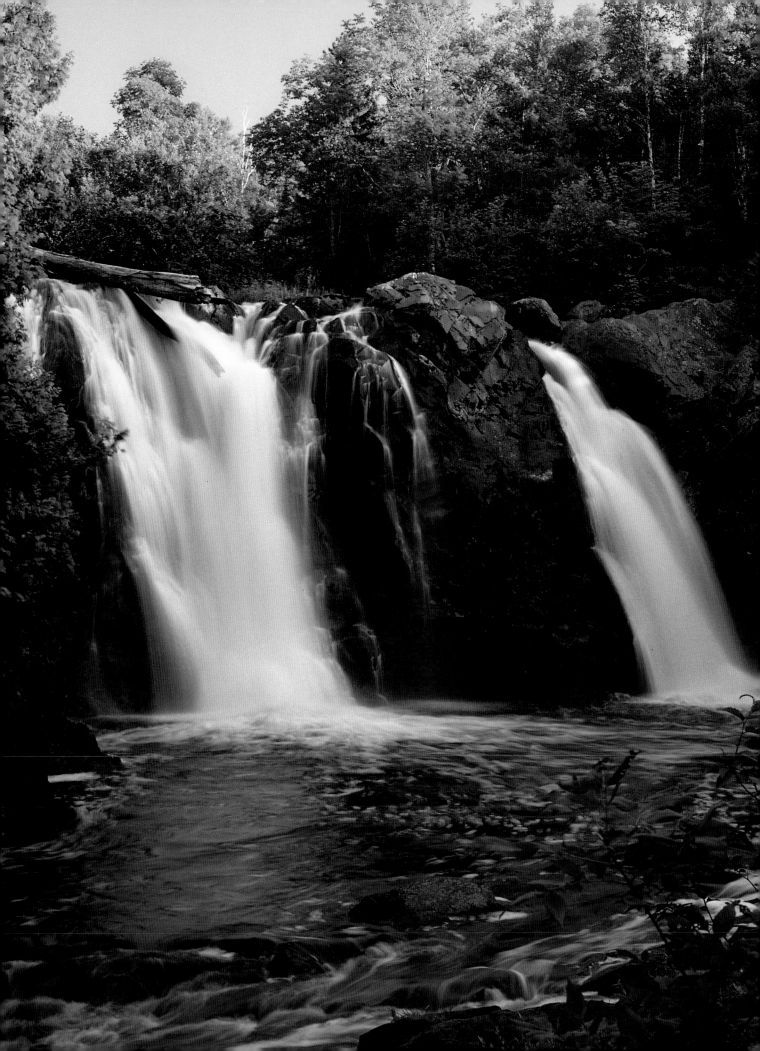

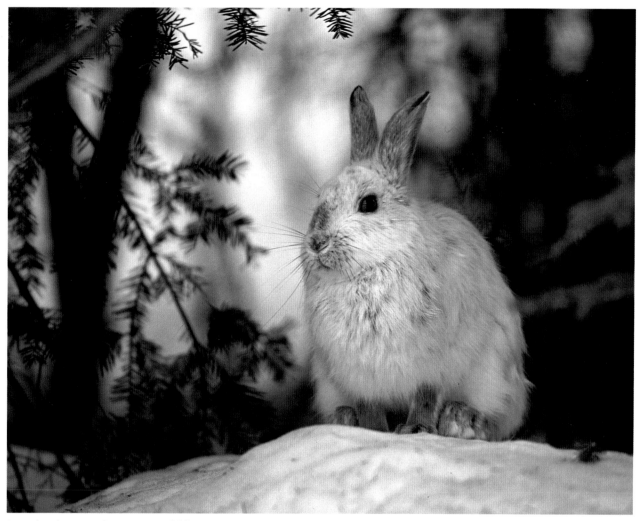

Snowshoe hare populations rise and fall, seemingly completing a cycle from low to high and down again within a decade. Perhaps they experience starvation due to overfeeding on willow, birch and aspen shoots that are not replenished quickly enough to meet this large rabbit's food needs. Possibly the plants are able to release chemicals into buds and twigs that cause damage to the hare's body chemistry or digestive functions.

Photo by Barbara Gerlach

Looking at the snow coatings of tree trunks along this river tells the direction from which the snow bearing winds came. Looking at the slush ice in the stream indicates that much of the snow stayed where it landed in this slow moving waterway.

Photo by Gregory K. Scott

Chequamegon Waters, Taylor County. The water evaporated from a river has frozen near its origin. The long needles of new frost indicate that the air was still during the previous night and the crystals formed slowly and intricately. Despite its complexity, ice never forgets the hexagon, the six-sided basis for all water crystals.
Photo by Gregory K. Scott

Winterberry holly. Colors are a way nature's creatures advertise. Sometimes the message is *stay away*. Sometimes it is *bet you can't see me. In the case of most brightly colored* fruits the message is clear: *Birds, with your color vision, come and get it!* Fruits contain seeds inside that can be freed for germination after the fruit coating is digested away. Fruits that are eaten give energy to the bird so that the seeds can be flown away and defecated in what might be new habitat for that plant.
Photo by John Gerlach

A shimmering curtain or an undulating veil – the descriptions of the northern aurora nearly always identify the movements that the viewer finds enchanting. Day or night, the aurora borealis may be active, but clear winter nights are the best time to see this manifestation of the earth's magnetic field and solar winds, and most favorable viewing conditions occur north of the Tension Zone.

Photo by Dr. Scott Nielsen